IMAGES
of America

HOUSTON
IN THE 1920s AND 1930s

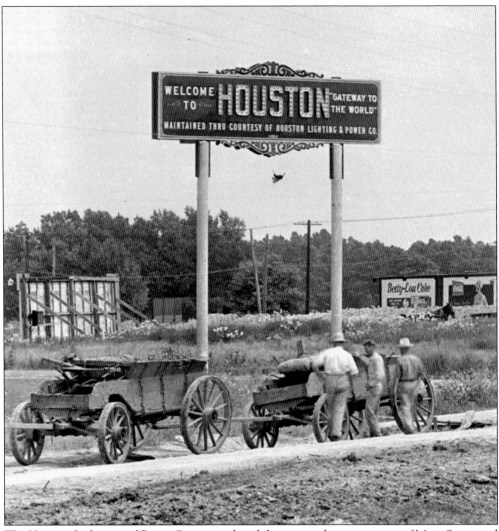

The Houston Lighting and Power Company placed this sign at the intersection of Main Street and Bellaire Boulevard. Its illuminated message—"Welcome to Houston, Gateway to the World"—was the first thing people would see at night as they entered the city from the south in 1928.

ON THE COVER: The Krupp and Tuffly shoe store Singles promotion (maybe referring to tickets) at the Metropolitan Theatre produced a large crowd of children waiting to see the 1930 Hollywood hit *The Texan*. The shoe store had an interesting gimmick where employees would use an x-ray machine to make sure the customer received a "perfect fit." (Sloane Collection.)

IMAGES
of America

HOUSTON
IN THE 1920S AND 1930S

Story Jones Sloane III

ARCADIA
PUBLISHING

Published by Arcadia Publishing
Charleston SC, Chicago IL, Portsmouth NH, San Francisco CA

Printed in the United States of America

Library of Congress Control Number: 2009920421

For all general information contact Arcadia Publishing at:
Telephone 843-853-2070
Fax 843-853-0044
E-mail sales@arcadiapublishing.com
For customer service and orders:
Toll-Free 1-888-313-2665

Visit us on the Internet at www.arcadiapublishing.com

*This book is dedicated to my father, Story Jones Sloane Jr.
Thanks to his efforts, a rare and historic part of
Houston's past has been preserved.*

CONTENTS

ACKNOWLEDGMENTS

As a collector of vintage and historic photography, I am constantly searching for that perfect negative. The combination of superb composition, exacting exposure, and precise development was the trademark of master photographer Calvin Wheat. His commercial photographic studio in Houston produced perfect images on a daily basis for a wide variety of clients. Calvin's reputation for being a creative and technical photographer would elevate him to the top of his profession in Houston. The photographs in this book cover a wide variety of subject matter dealing with vintage and historic Houston. They were created by working professional photographers at the request of their customers. It by no means is a complete representation of all aspects of life in Houston.

My father, Story Jones Sloane Jr., was born in 1928, and his first formal baby portrait was made by Calvin Wheat. Calvin never knew that the infant he was photographing would grow up to save a portion of his best work.

All images in this book are provided courtesy of the Sloane Collection.

INTRODUCTION

Houston is like no other city in the world. It was named after Sam Houston, the hero of San Jacinto, and lies just a short distance from the birthplace of Texas liberty. It is a Texas-sized 640 square miles of interlocking roadways and bustling citizenry. What started out in 1836 as a muddy, mosquito-infested tent city has evolved into a modern-day Space City. After all, the first word spoken from the moon back in 1969 was "Houston." The famous oil strike at Spindletop in 1901 just east of town heralded the beginning of the oil industry in Houston, which would lead to the city's reputation of being the energy capital of the world. It was once described as a city where 18 railroads meet the sea, and today the port of Houston is the second largest in the nation with a multi-billion-dollar impact on the local economy. The bountiful geography of East Texas would produce an abundance of cotton and timber that would flow through Houston, providing economic opportunities and turning many of its early citizens into millionaires.

The two decades of Houston's photographic history represented in this book illustrate remarkable achievements in commercial growth and community development. The belief that Houston was the number-one city of opportunity in the South became a reality for hundreds of new entrepreneurs every year. The horse-and-buggy mode of transportation would go the way of the buffalo that once roamed the area. City streets that at one time resembled a sea of mud became bricked boulevards lined with commerce. Main Street Houston stretched from the banks of Buffalo Bayou through downtown and southward toward Rice Institute and Hermann Park. Historically the foot of Main Street began at Buffalo Bayou. Commerce Street was the first cross street and home to the produce market. Commodities would arrive daily by truck, plane, and train. The local growers would bring in produce loaded in horse-drawn wagons from area farms. The financial district was comprised of several banks, anchored by First National and Houston National Banks, that flanked Main Street and started at Franklin Avenue. Retail stores full of all types of merchandise would occupy almost every square foot of ground-floor space from Congress Avenue to Lamar Street.

The city was expanding at a rapid pace. In 1910, Houston was 16 square miles, and by 1920 it had grown to 38 square miles. By 1929, it had bloomed to over 72 square miles with a population of almost 300,000. New home subdivisions were springing up all over town. The River Oaks Country Club Estates to the west and Monticello development to the south represented two different income levels of home building. Almost every neighborhood had a drug or grocery store close at hand. The weekly delivery of ice became a thing of the past, as electric refrigeration was made available to the citizens. There were no more mule-driven milk wagons. They were replaced by gasoline delivery trucks in the 1930s.

The Great Depression would have a moderate impact on Houston. The meteoric building period the city experienced in the 1920s would slow down for most of the 1930s. The continuing expansion of the Houston ship channel provided an impressive financial lifeline for the city. Revenues generated by the industries that lined the ship channel would keep the worst of the national Depression away. The working load was lightened by the advances of electricity. Air-

conditioning for both the home and office would break the stranglehold of Houston's harsh climate, encouraging additional business to relocate here.

The region's reputation for abundant recreational opportunities was well deserved. At 49 miles an hour, the interurban train could take local beachcombers from downtown Houston to Galveston, Texas. The soothing warm waters of the Gulf Coast were a little more than an hour away. Just east of town in La Porte was Sylvan Beach. It was a 25-acre popular vacation spot just 30 minutes from town. It featured bands, carnival rides, and good barbeque. The major movie theaters were air-conditioned by the end of the 1930s, and all of the major Hollywood films came to town. Houston Speedway on the south side offered automobile racing. On rare occasions, people would even race airplanes against the cars. The Houston Buffaloes baseball team attracted thousands to the new Buff Stadium, erected in 1928 at a cost of $500,000. Babe Ruth and the New York Yankees would play exhibition games with the Buffaloes and in 1930 creamed the home team 17-2.

It was clear the options for play in historic Houston were plentiful, but the community never forgot those who were less fortunate. The Community Chest (United Way) was organized in 1922 with a $400,000 goal to help 22 organizations. In 1930, with support from hundreds of volunteers, their goal was increased to a lofty $514,000. The Kiwanis Club sponsored baseball outings for underprivileged boys, and the Girl Scouts had a large camp down in Clear Lake. The Democratic National Convention came to town in the summer of 1928, giving the rest of the nation a glimpse of modern Houston. Local business icon Jesse Jones's $200,000 contribution and political influence was responsible for Houston getting the venue. Sam Houston Hall was built in record time to house the convention, held in June 1928, and was utilized until it was replaced by the Sam Houston Coliseum in the late 1930s. One of the big debates on the convention floor revolved around the ending of Prohibition.

There was a time when getting around anywhere in the Republic of Texas required a large team of oxen and a sturdy cart. In less than 100 years, the transportation system around Houston would contain multiple rail lines and 72 steamship lines.

The Houston Municipal Airport on Telephone Road was chartered in 1927. In 1931, the first airway radio communications station was set up. Air traffic was increasing in all areas. Commercial passenger airlines like Eastern came to town in the 1930s, and air flight schools opened for the public. The continuing growth of the oil industry was evident by the fact that in 1938, over 120 million barrels of oil were produced within a 150-mile radius of Houston. The frontier spirit and determination of the Houstonians who built the city in the 1800s can be witnessed in the accomplishments of its citizens in the 1920s and 1930s.

One

MAIN STREET

The Rouse Drug Company and Store was located at 1101 Main Street on the southeast corner of Main and Lamar Streets. Sam Rouse was the president. The outstanding architectural detail found on this building is rarely used in construction today.

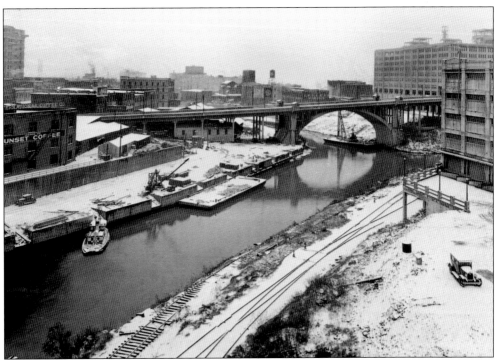

This image was made from atop the Peden Iron and Steel Building on San Jacinto Avenue. It shows the confluence of Buffalo and White Oak Bayous during a rare snowstorm in 1929.

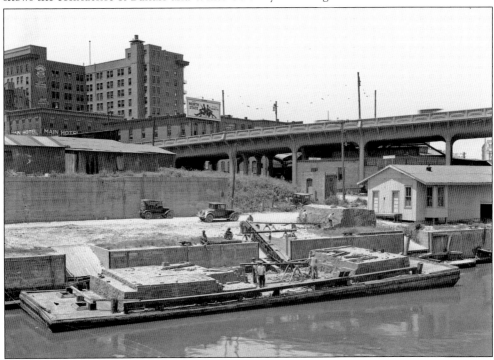

Even though the Houston ship channel and turning basin bore the majority of commerce, there was some limited barge traffic still docking at the foot of Main Street in 1931.

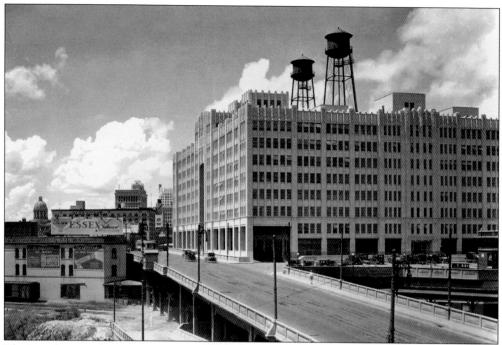

The Merchant and Manufacturing Building was the tallest structure just north of Buffalo Bayou on Main Street. Completed in 1930, it had 700,000 square feet of space and 14 elevators.

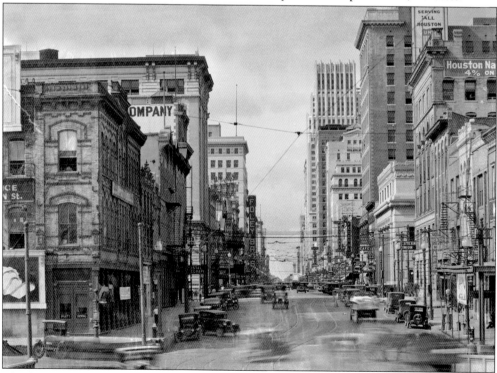

The first cross street on Main Street was Commerce Street, as seen here looking south in 1928. The produce market and warehouses were concentrated on this street.

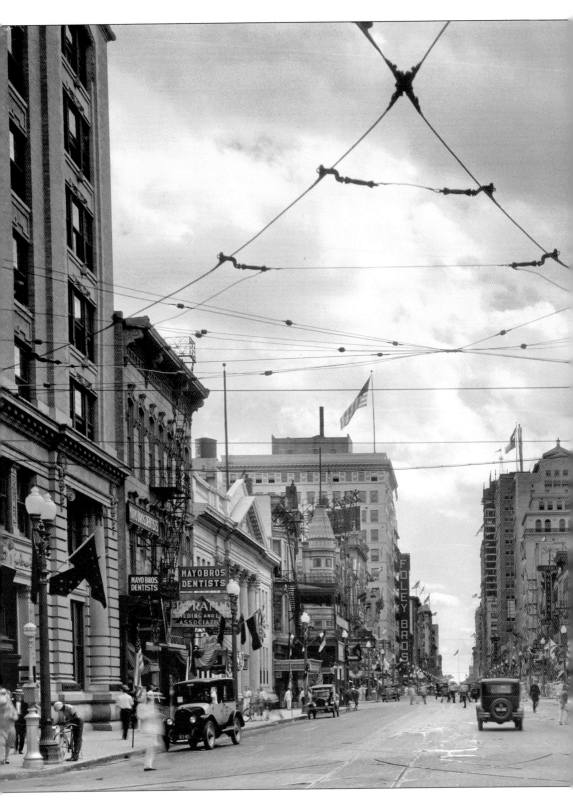

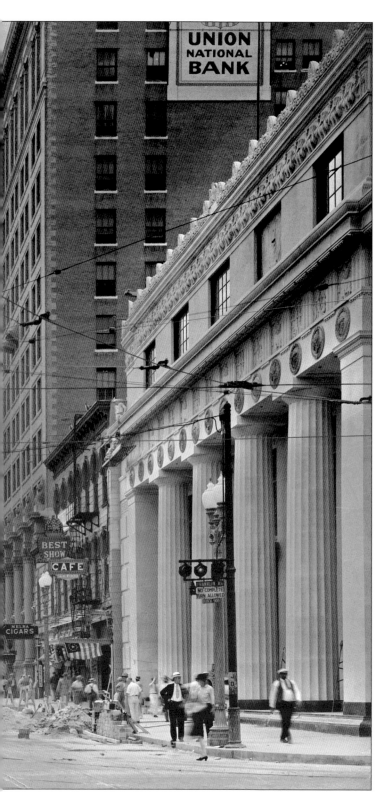

This photograph, taken in the middle of Main Street at the intersection of Franklin Avenue, was made June 28, 1928. It is a perfect illustration of how Houston prepared for the Democratic National Convention. The state delegate flags that adorned every light post down Main Street were combined with American flags and banners hanging from the buildings. This part of town was also know as the banking, or financial, center of Houston.

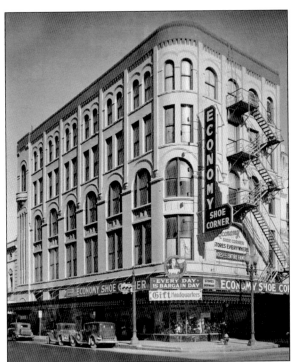

The Kiam Building, constructed in 1893, was located at 320 Main Street. Originally it was a five-story clothing store, but as this photograph shows, in the 1930s it was converted to a discount shoe store.

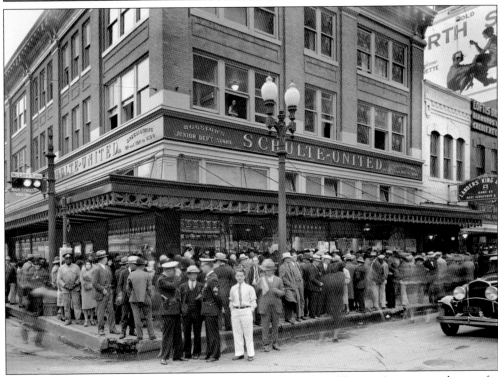

Located at 501 Main Street, the Schulte United Store was one of Houston's many retail stores for juniors. Items started out at 5¢ and went up to $1. During this special promotion, even turkeys were added to the inventory for 25¢.

One of Houston's oldest retailers was Foley Brothers Dry Goods Company. Shown here in 1928 is an employee of the hat department fitting a customer with the popular cloche (bell) hat. They were offered at prices ranging from $1.50 to $4.

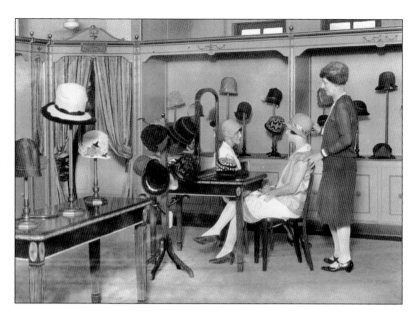

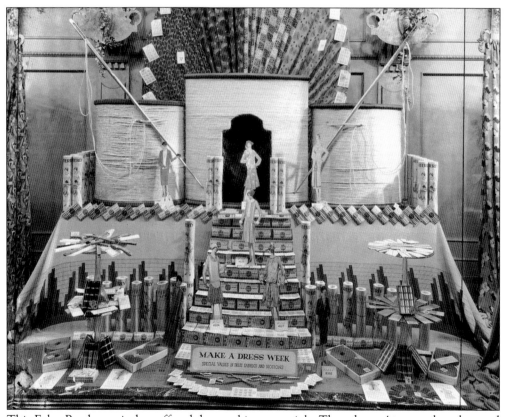

This Foley Brothers window offered dressmaking materials. Thread was 4¢ a spool, and a good pair of scissors would cost a person 59¢. This store at 407 Main Street would move down to Main at Lamar Street in the late 1940s.

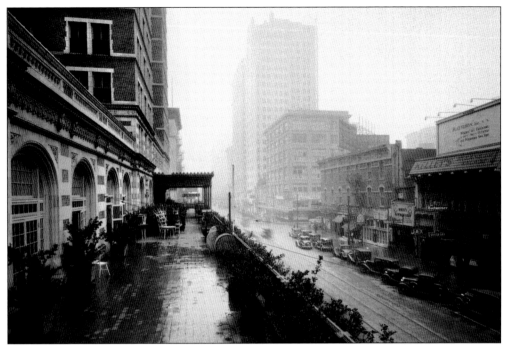

The mezzanine of the historic Rice Hotel is pictured looking east down Texas Avenue at the Main Street intersection on a misty Sunday morning. The Rice Hotel was one of Jesse Jones's first building ventures. Its location is where the first capital of the Republic of Texas stood.

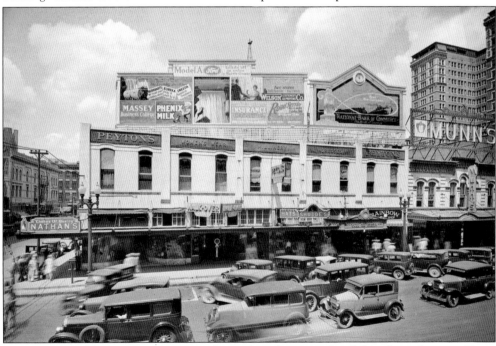

This whole city block of retail stores was located on the west side of Main Street between Texas and Capital Avenues. The city removed the trolley tracks on Main Street in 1925 to allow for better traffic flow. This block was razed for a multilevel parking garage.

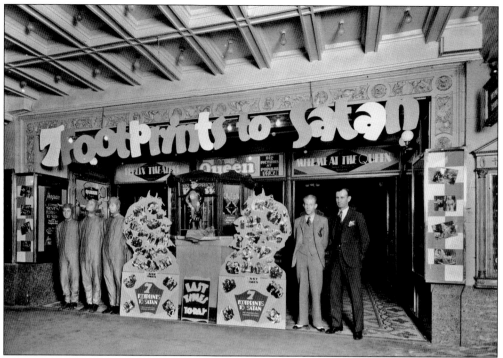

The Queen Theatre was located at 613 Main Street. Shown here in 1929 are the ushers dressed in costume for the showing of *7 Footprints to Satan*.

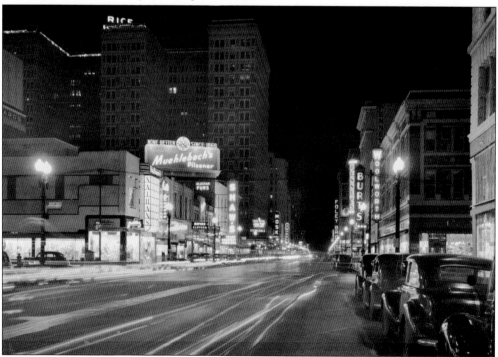

Night traffic on Main Street at Rusk Avenue is pictured here in 1939 looking north. Red Nichols and his Five Pennies Band were playing at the Rice Hotel's famous rooftop dancing pavilion.

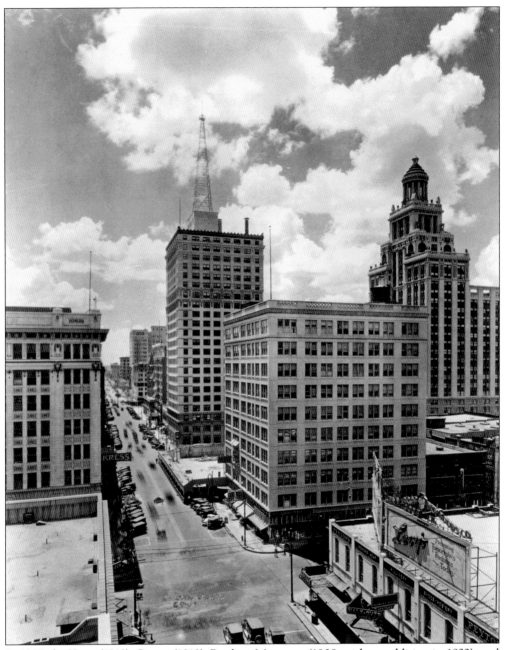

In 1927, the Kress (1913), Carter (1910), Bankers Mortgage (1908, with an addition in 1922), and Esperson (1927) Buildings dominated the skyline around Main Street at Capital Avenue.

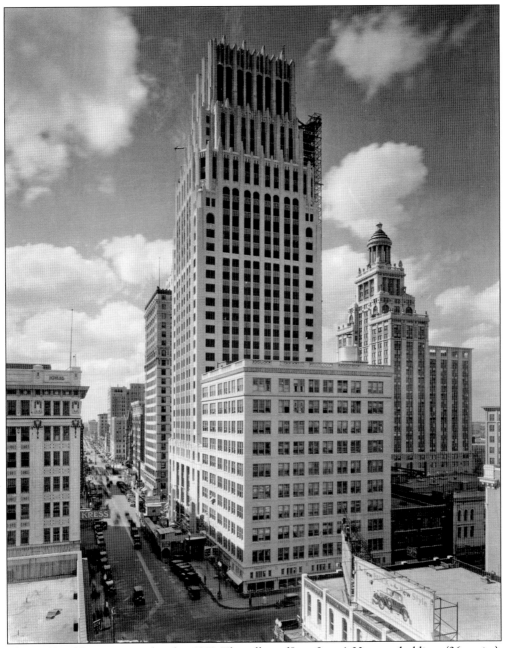

The Gulf Building was completed in 1929. The tallest of Jesse Jones's Houston holdings (36 stories), it would dominate the skyline for decades. It still stands today as a rare example of Houston's past architectural treasures.

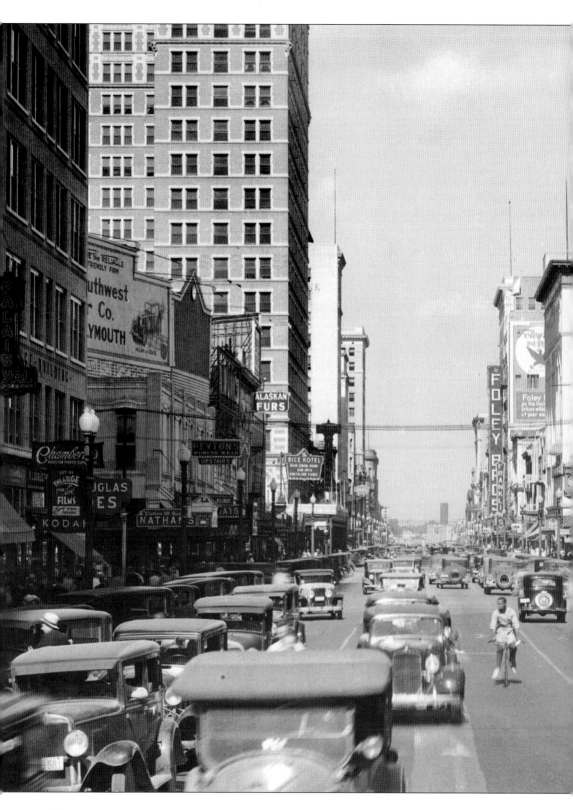

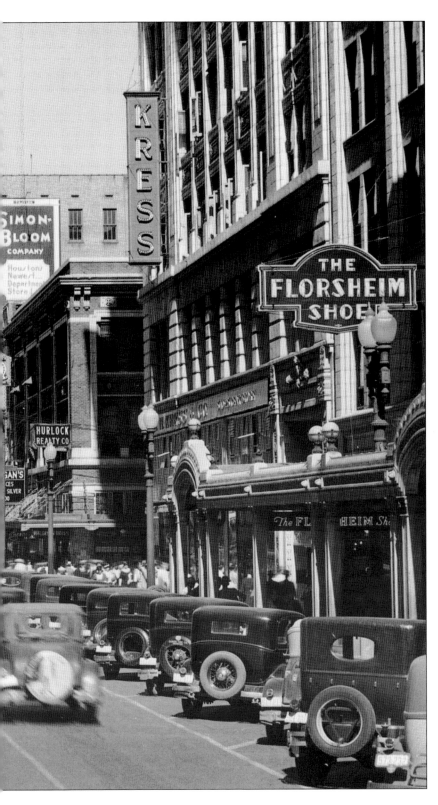

In the mid-1930s, retail traffic on Main Street was near its peak. As the population started to spread outward, away from the heart of downtown in the 1940s and 1950s, so went the merchants. It is unlikely that Main Street will ever see this type of activity in the future.

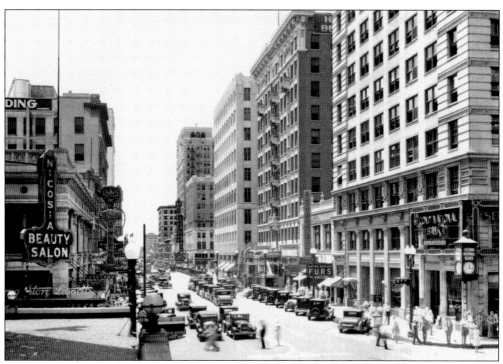

The Second National Bank, Battlestein's, the Bender Hotel, Levy Brothers, and the Lamar Hotel flank the west side of Main Street looking south in 1928.

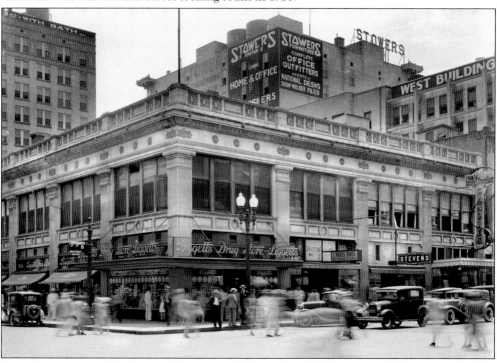

Louis Liggett started his chain of 40 stores in 1902, and by 1925 there were 300 nationwide. The Houston store was located on the southeast corner of Main Street and Rusk Avenue.

Window dressing was big business in Houston, and this Liggett's drugstore display is a good example of a 1928 design. The cost of 10¢ for a box of cough drops included oils of turpentine, camphor, thyme, cedar leaf, and nutmeg as ingredients.

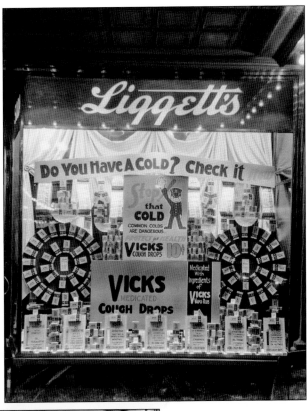

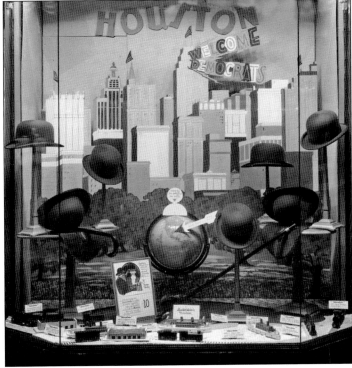

This Battlestein's store window was specifically designed for the National Democratic Convention delegates who were in Houston in June 1928. The pro Smith brown Derby sold for $10. Smith was up for a presidential nomination at the convention.

The Bender Hotel, built back in 1911, received a substantial renovation in 1930 at a cost of $350,000. It was reopened as the San Jacinto Hotel in 1931.

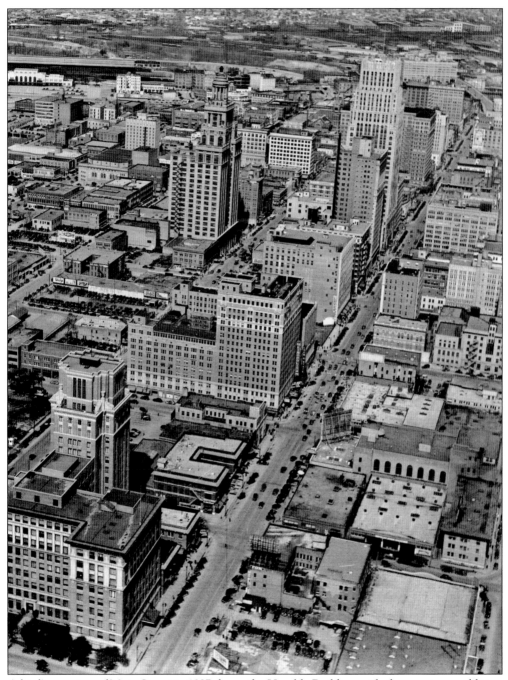

A bird's-eye view of Main Street in 1937 shows the Humble Building with the new tower addition (bottom left). The Gulf Building (above right) would remain the tallest downtown structure for decades.

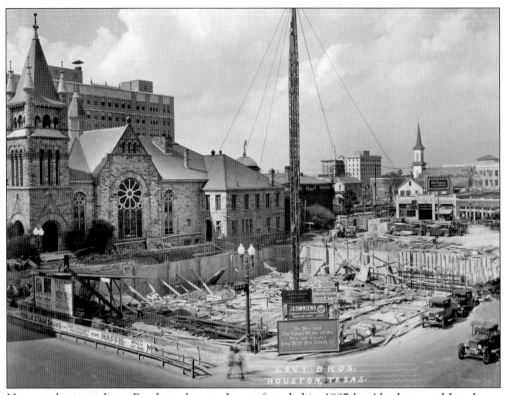

Houston business Levy Brothers dry goods was founded in 1887 by Abraham and Leo Levy. Their new store on the southwest corner of Main Street and Walker Avenue sat right next to the historic First Presbyterian Church. The building was designed in 1928 by popular local architect Joseph Finger.

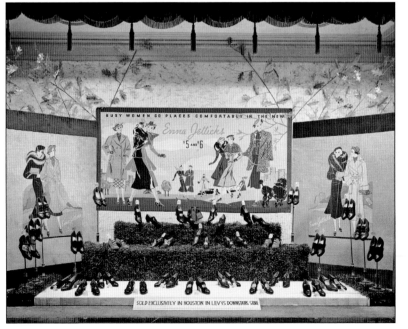

Once completed, the Levys' new store window design featured Enna Jetticks shoes for the bargain price of $5 and $6.

The construction of the new Krupp and Tuffly shoe store in 1929 at the corner of Main Street and Walker Avenue carried on a historic tradition of keeping the business on a Main Street location since 1882. They had customers as far away as China.

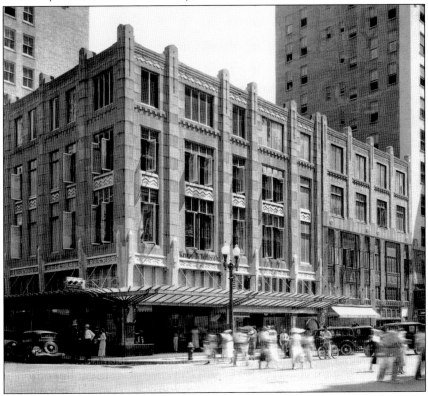

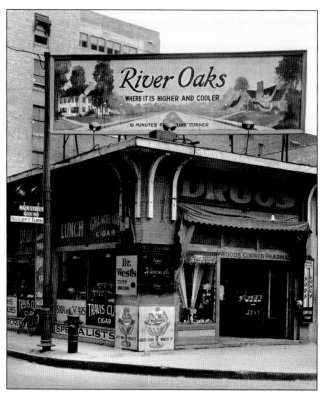

This advertising sign at the 900 block of Main Street was promoting the subdivision of River Oaks. Its claim of the neighborhood's elevation being higher than the rest of the city, and therefore cooler, was dubious.

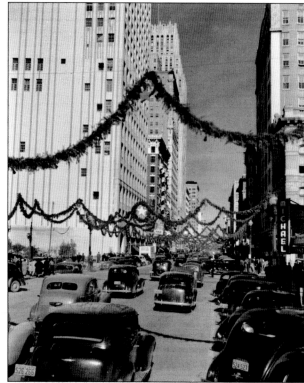

Christmas decorations line Main Street in 1939. The heavy pedestrian and street traffic indicate a continuing healthy retail trade leading into the next decade.

The intersection of Main and Lamar Streets is shown looking north in 1930. The Metropolitan, Lowes State, and Kirby Theatres provided nighttime entertainment featuring the latest film releases.

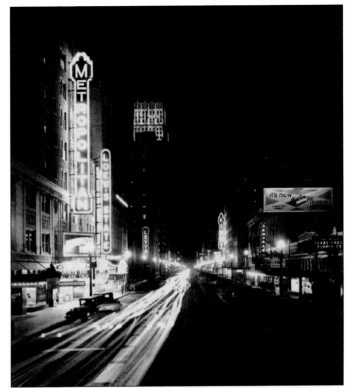

The Lamar Hotel was constructed in 1926; the famous room 8-F had the reputation of being the place where the movers and shakers of Houston and Texas politics would meet.

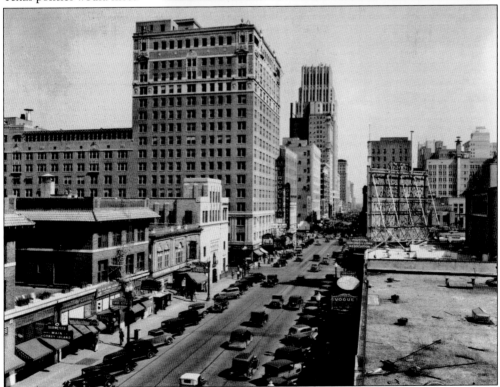

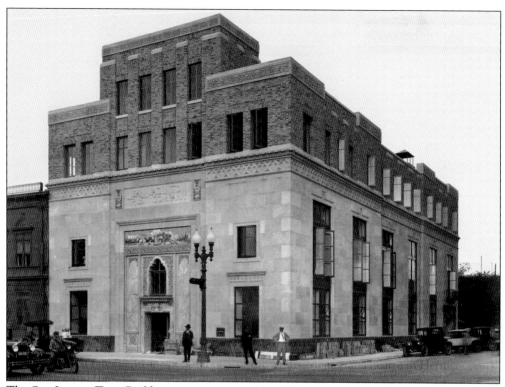

The San Jacinto Trust Building was constructed in 1927 on the southwest corner of Main and Lamar Streets. The business opened in 1920 and closed by voluntary liquidation in 1934, lasting less than 15 years. The new 1927 building lasted only a few years more and was demolished in the 1940s to make way for the new Foley's Department Store.

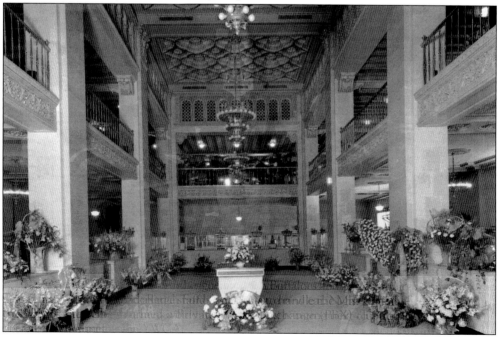

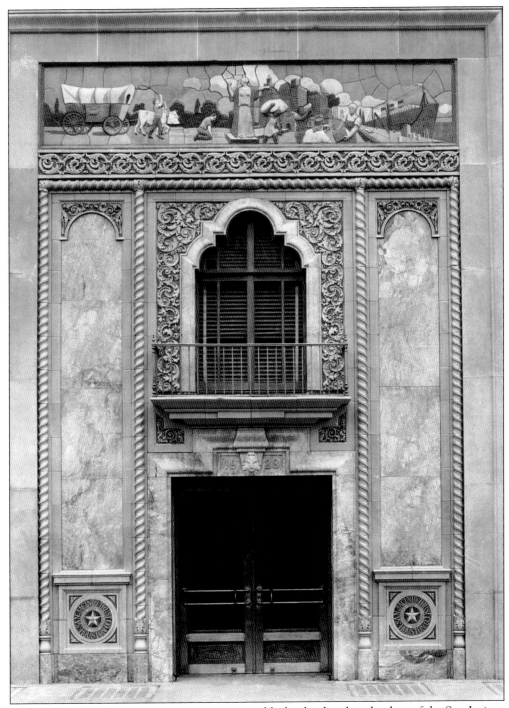

The Atlantic Terra Cotta Company was responsible for the detail in the door of the San Jacinto Trust. The company, founded in 1887, closed in the early 1930s because of the economic effects of the Depression. This magnificent part of Houston's architectural past lasted less than 20 years.

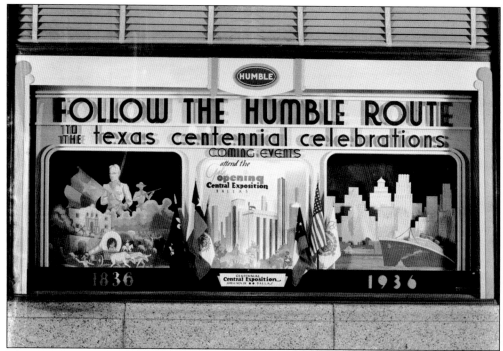

The Humble Oil Building on Main Street utilized its windows for a wide variety of community announcements. This 1936 design promoted the upcoming Texas centennial celebrations.

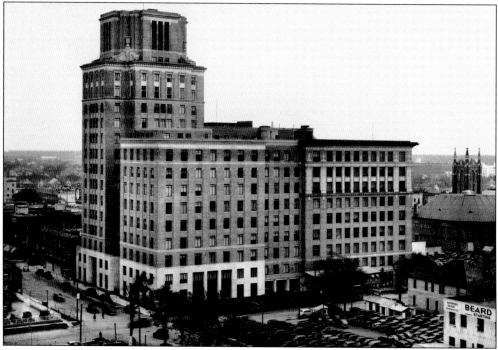

The Humble building was constructed in 1921 and was home to the Humble Oil and Refining Company. A $750,000 seventeen-story tower annex was added in 1936. The company had the distinction in 1932 of being one of the first office buildings to be centrally air-conditioned.

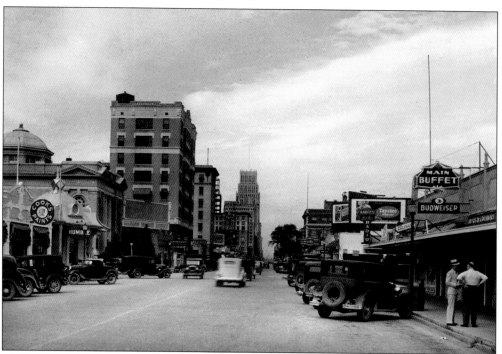

This 1934 image of Main Street at Jefferson Avenue looking north reveals that the high-rise office construction popular in downtown Houston was not progressing south at this time.

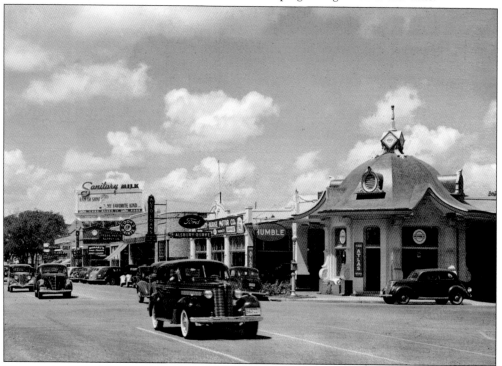

This south view of the same intersection in 1934 shows the first gas station of the Humble Oil Company on the right.

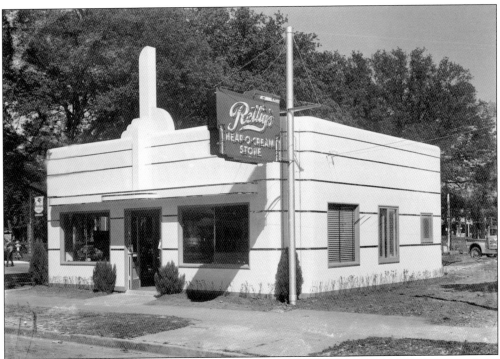

In 1930, Penn Rettig's ice cream could be found in almost every establishment that served the frozen concoction. This Heap O Cream store was located at Main Street and Elgin Avenue.

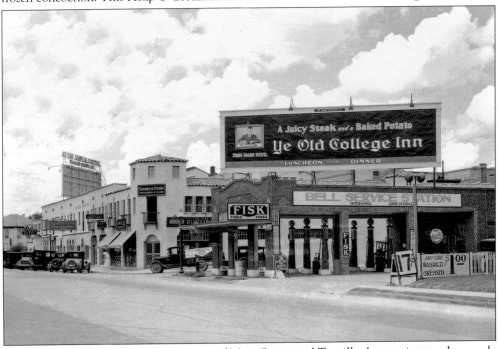

This 1928 strip center at the intersection of Main Street and Truxillo Avenue is a good example of the retail expansion to the south. The Ye Old College Inn was a popular Houston restaurant landmark for decades.

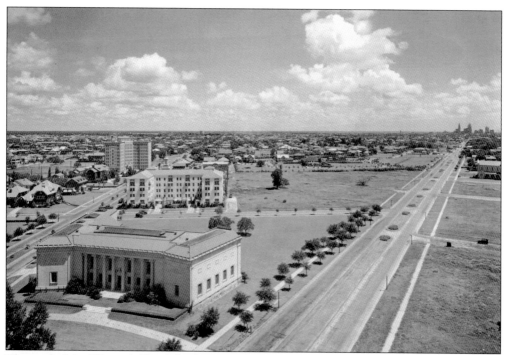

The roof of the Warwick Hotel (built in 1925) proved to be the perfect location to photograph Main Street looking north in 1928. The Museum of Fine Art (1924) is in the foreground, complete with the 1926 wing additions. The Plaza Hotel (1926) is on the extreme left, and the Gulf Building under construction can be seen on the horizon.

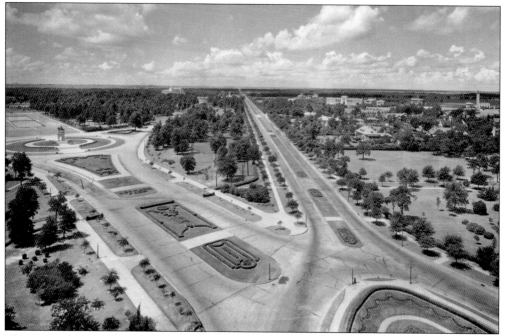

The same photographer turned the camera to the south from the same location and captured Hermann Park and Hospital to the left and Rice Institute to the right.

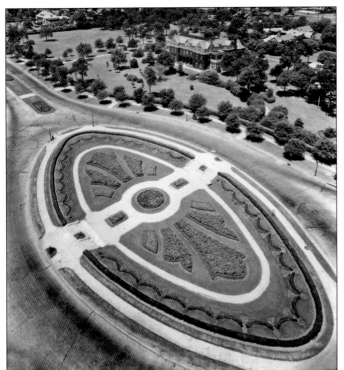

The Sunken Garden sat in the middle of Main Street in front of the exclusive Shadyside subdivision. It was replaced by the Mecom Fountain in 1964. The Mansion Shadyside at the top of the photograph was the home of Joseph Cullinan, the founder of Texaco Oil. It was razed in 1972.

The Sam Houston statue (erected in 1925) in Hermann Park was a favorite backdrop for everybody who owned a camera. Here a local bathing beauty adorns the hood of a 1929 Nash. In the background is the Warwick Hotel.

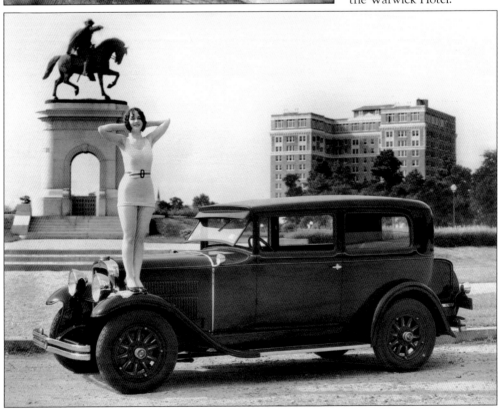

Two

HOME LIFE

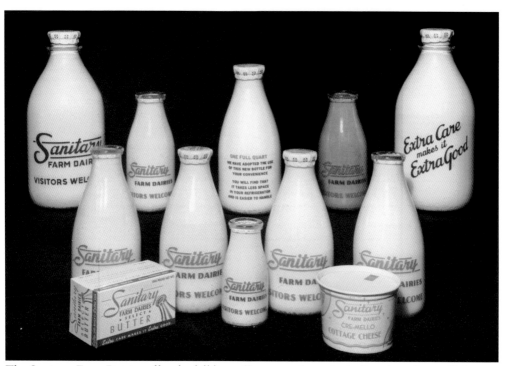

The Sanitary Farm Dairies offered a full line of home products, including chocolate milk, butter, and cottage cheese. Also featured is a new bottle designed to save space.

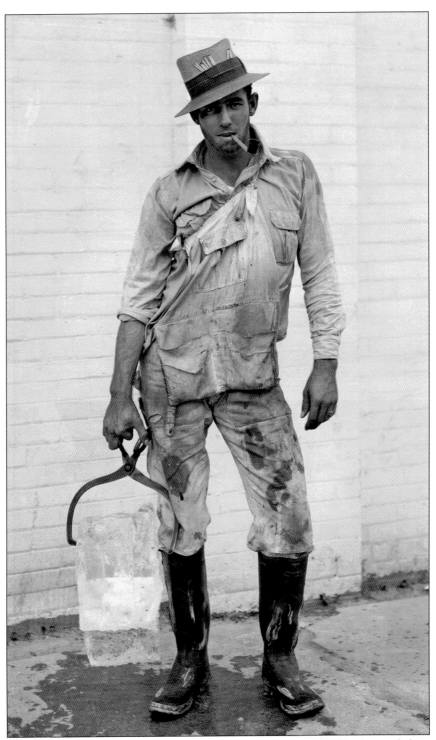

This iceman worked for the Home Ice Company in 1928. He is holding a 25-pound chip off of a 100-pound block. Once the delivery trucks were loaded, a properly attired iceman would handle domestic delivery.

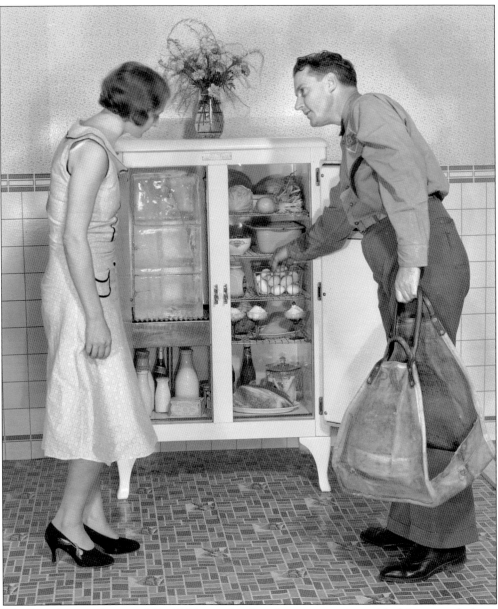

This brand-new icebox would hold 75 pounds of ice. It came complete with drip pan and a large storage capacity. If the ice was running low, the homeowner would place a numbered window card stating how many pounds were needed in plain sight for the delivery driver.

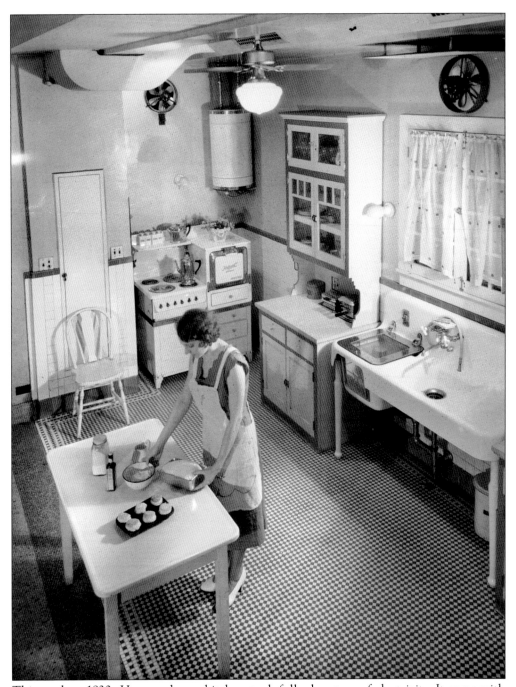

This modern 1930s Houston home kitchen took full advantage of electricity. It came with a built-in ironing board plus electric fans, water heater, stove, oven, waffle irons, coffeepots, and dishwasher.

The oldest drugstore in Houston was Burgheim's Pharmacy. It was established in 1881 and by 1933 claimed to have filled over 800,000 prescriptions.

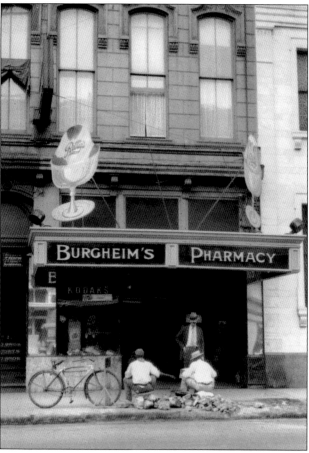

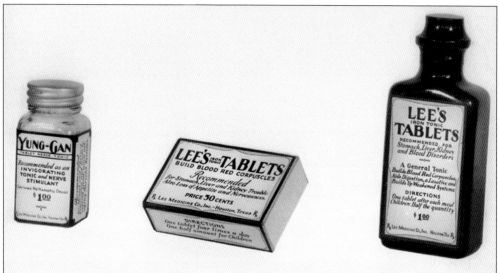

In 1931, the Lee Medicine Company opened in the Scanlan Building in office 308. Organized by major stockholder J. J. Rushing, they offered pills and tonics to stimulate nerves and cure stomach and kidney problems.

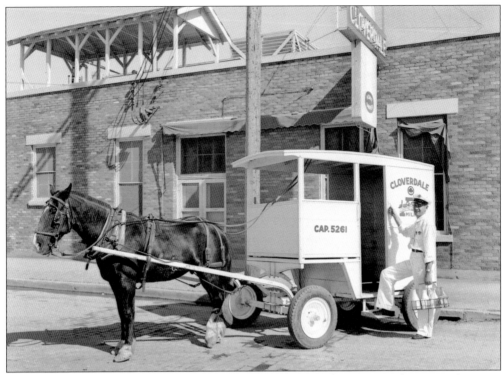

The modernization of Houston in the early 1930s was proceeding at a rapid pace, as the main means of transportation shifted from horse to automobile. The familiar neighborhood mule-drawn milk wagon making home deliveries was replaced by the brand-new refrigerated, gasoline-fueled truck. Cloverdale Creameries was located at 34 North Hamilton Street.

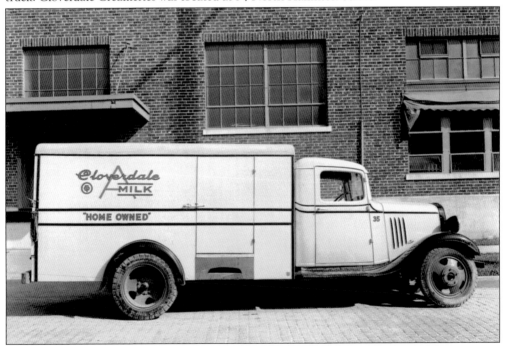

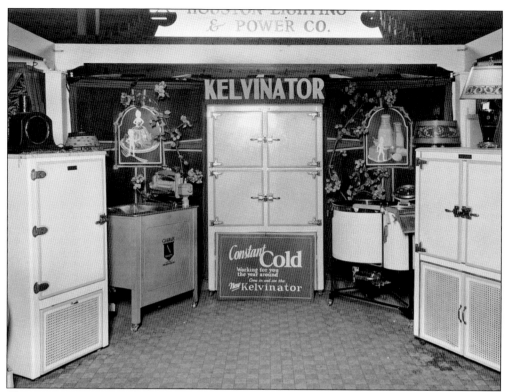

This 1930s Houston Lighting and Power public display promotes not only the use of electricity but the new technology of the Kelvinator refrigerated icebox. The company had stores in all surrounding Houston communities demonstrating new advances in electrical convenience.

The electrical appliance store concept was making its entry into the Houston market during the late 1920s, and Houston Lighting and Power was leading the pack. The home use of electricity was no longer confined to illumination, and HL&P made sure, through countless demonstrations and promotions, the public knew it.

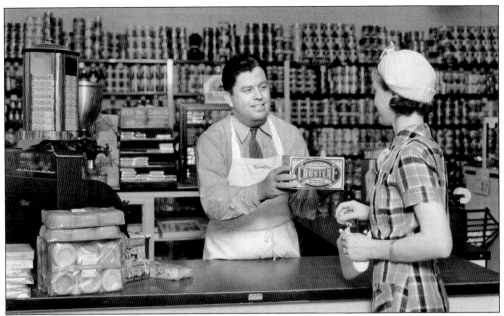

The South Texas Cotton Oil Company in Houston manufactured cottonseed oil and byproducts. Crustene was used for shortening and frying. A salesman from Nowells grocery and market at 2403 Taft Avenue is pictured selling Crustene to a customer in 1931.

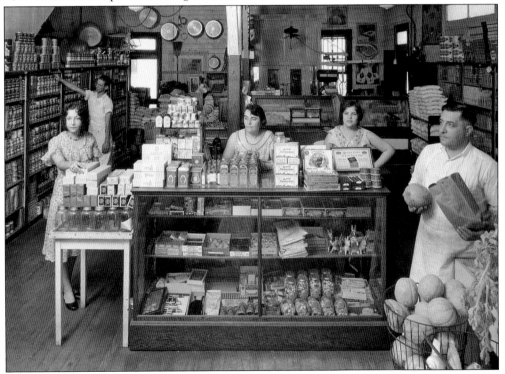

The State Street grocery, located at 1602 State Street, was owned by Samuel Rosenberg. It was typical of owners of local neighborhood mom-and-pop grocery stores to live and work in the same building. This 1928 photograph shows the family ready for business.

Tony Navarro's grocery store was located at 1115–1117 Crockett Street. He was a member of the Independent Grocers Alliance of America. In 1928, pork and beans in his store sold for 9¢ a can and a box of Ivory flakes cost a dime.

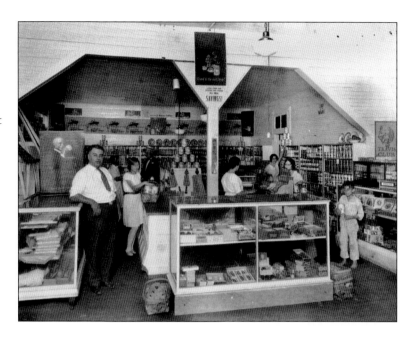

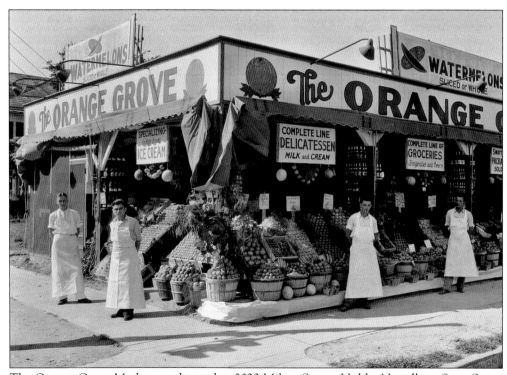

The Orange Grove Market was located at 2020 Milam Street. Unlike Nowells or State Street grocery, they offered more of an outdoor produce market atmosphere. This image of their produce handlers was made in 1933.

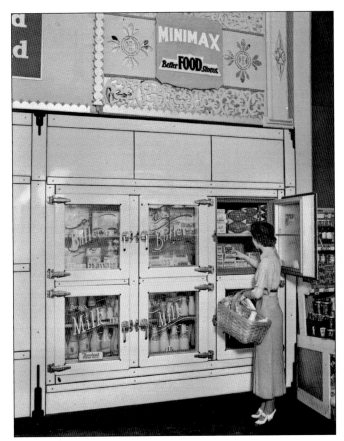

In 1935, Minimax had three grocery stores in Houston. Customers never had to handle the goods, just point at an item and the employees would bag it for them. The photograph to the left was made at store No. 1, at 1206 Westheimer Road, and below is store No. 2, at 5212–1516 Almeda Road.

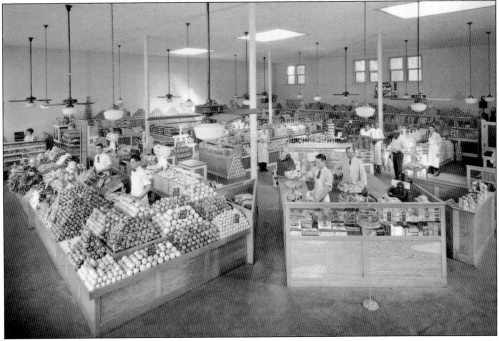

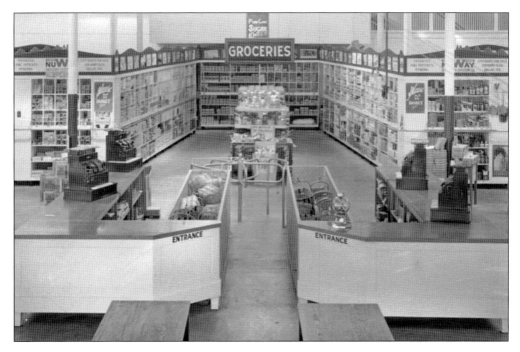

One of the most well-known grocery stores in Houston was Henke and Pillot. This 1928 photograph shows the main store located at 702 Congress Avenue. When this company expanded in the 1920s, they made allowances for automobile parking adjacent to their stores in order to attract the mobile shopper. The interior image of the Congress location shows the introduction of the NuWay Grocery System.

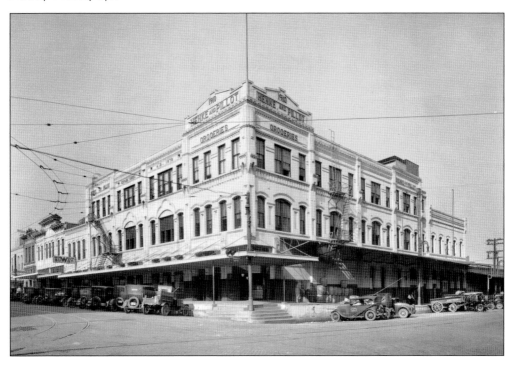

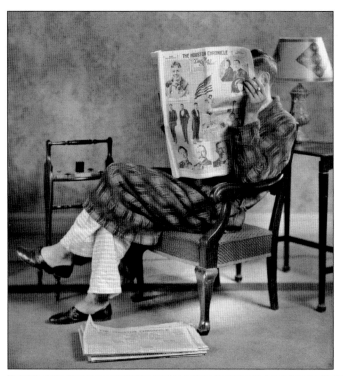

The *Houston Chronicle* is the oldest newspaper in town. It was started in 1901 by Marcellus Foster and acquired by Jesse Jones in 1926. This gentleman is enjoying his June 12, 1927, morning paper.

The Jones Newsstand on Texas Avenue was directly across the street from the Rice Hotel. The 1935 *Saturday Evening Post* series of Louisiana governor Huey Long was just released September 7; unfortunately Huey Long was assassinated September 9.

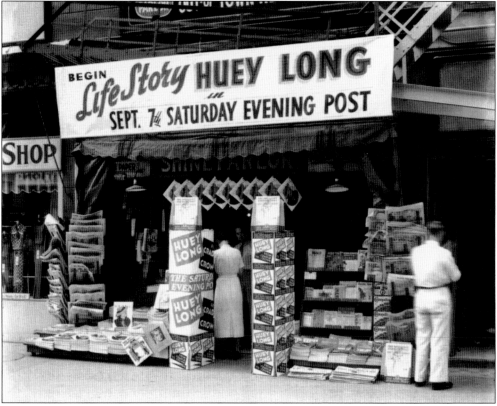

The Houston office of the National Biscuit Company was located at 3–19 North Chenevert Street. This 1928 product shot is a classic example of what could be found in countless pantries in Houston.

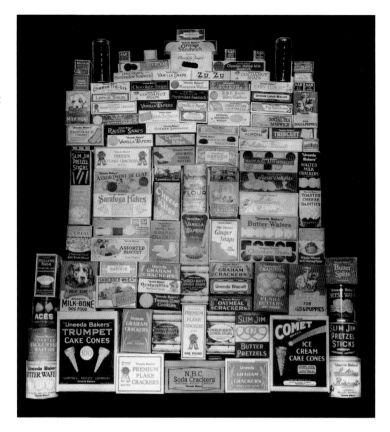

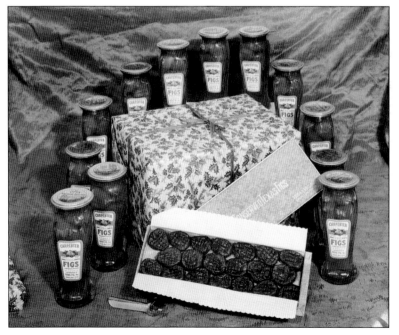

The climate of Houston made it the perfect environment for growing Magnolia figs. In 1931, the area produced over 6 million pounds of figs and had six canning plants to process them. In 1932, the Houston Chamber of Commerce presented 720 jars of preserved figs to the officers and crew of the USS *Houston*.

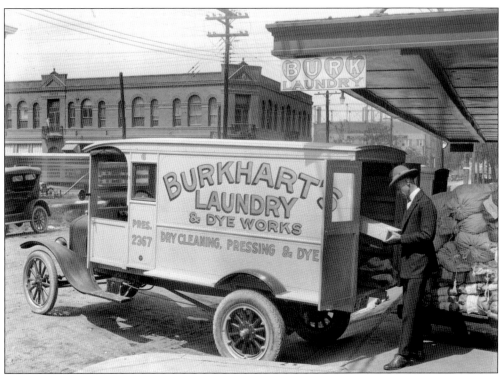

The city of Houston had dozens of laundries to service its growing population. Home delivery was standard service at companies like Burkhart's Laundry at 1700–1704 Congress Avenue and American Laundry located at 1304 Washington Avenue. Along with the home market, Houston's growing hotel trade kept the industry healthy.

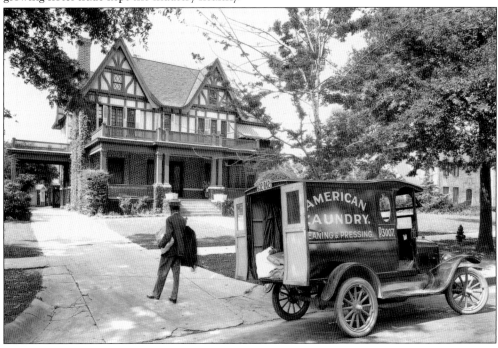

The daily task of cleaning up after a hard day's work was made more comfortable with the convenience of hot water. The Sutter Water Heater and Plumbing Company was run by W. T. Sutter Sr. and Jr. This 1929 image was made at their 1509 Louisiana Street location.

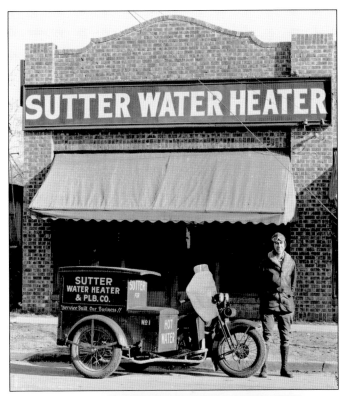

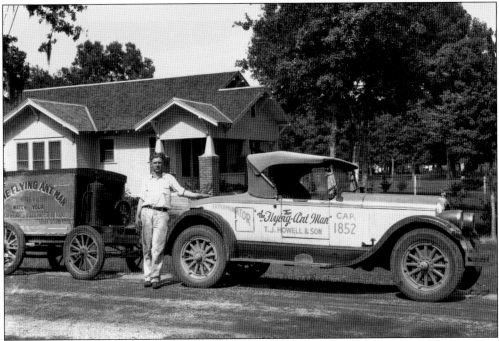

One of the more unpleasant facts about living in Houston was the presence of termites. This 1928 photograph of exterminator T. J. Howell shows his slogan—"The flying ant man"—painted on his car.

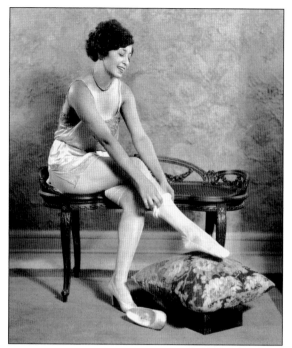

These brand-new silk stockings from Foley Brothers Dry Goods store could only handle the most delicate of care. That same level of care was found within the dying and dry cleaning industry in Houston. Artistic, or "A," cleaners offered both services. Their dying process could make an old dress look new. They were located at 1419 West Webster Street. Dry cleaning was really not dry, and in the 1920s the petroleum solvent stoddard was used in the process.

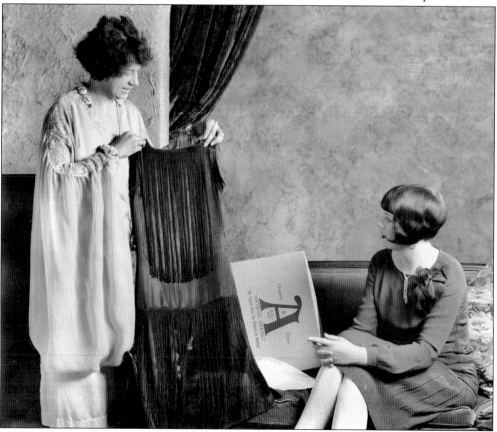

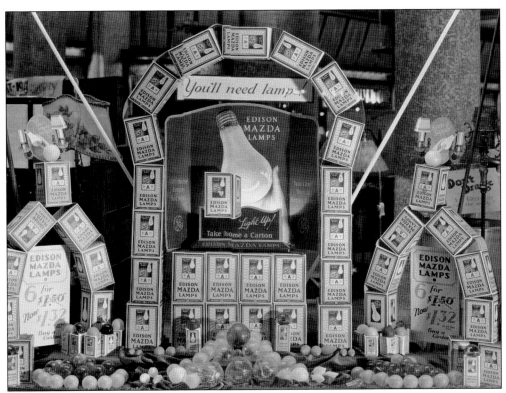

This Edison Mazda lightbulb display was in the Houston Lighting and Power Building's window at the southwest corner of Fannin Street and Walker Avenue. It is another example of the company's ongoing campaign to promote electricity. Six lightbulbs cost $1.32 in 1929.

In the early 1930s, there was a bread war in Houston among bakers that caused much economic strife in the industry. Wholesale bread companies like the Texas Bread Company, pictured here in 1927, were fortunate to survive.

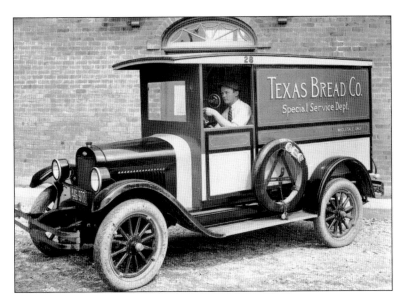

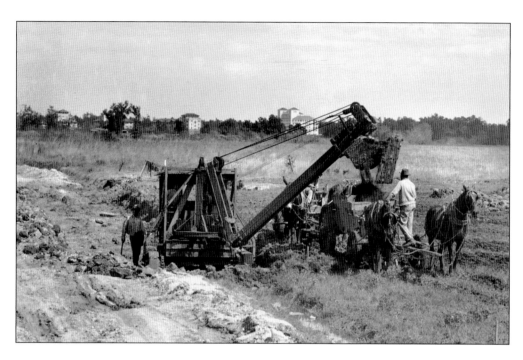

In the late 1920s, the city was spreading to the south, and home subdivisions were added to accommodate the growth. Rice Institute and Hermann Hospital can be seen in the background (above) as construction of a new street moves forward. The corner of Sunset Boulevard and Belmont Avenue (below) was the home for the sales office of the Monticello development.

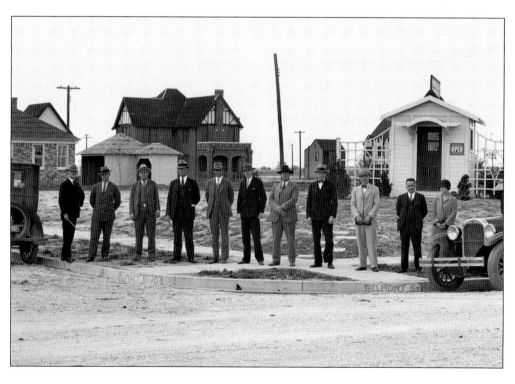

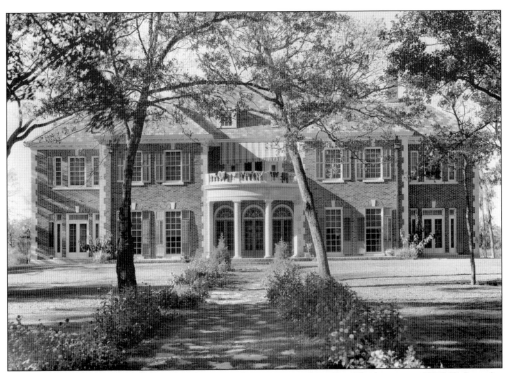

Oscar Holcombe served as Houston's mayor for over two decades. His home at 1905 Holcombe Boulevard, pictured here in the 1930s, is now the location for Houston Hospice.

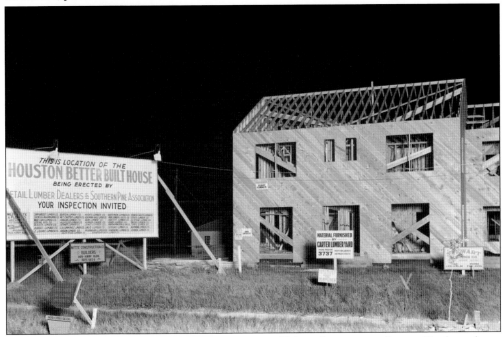

This new 1930s home construction project west of Main Street near Sunset Boulevard was promoted by the Retail Lumber Dealers and Southern Pine Association. The night photography was accomplished with an open shutter and multiple flash exposures.

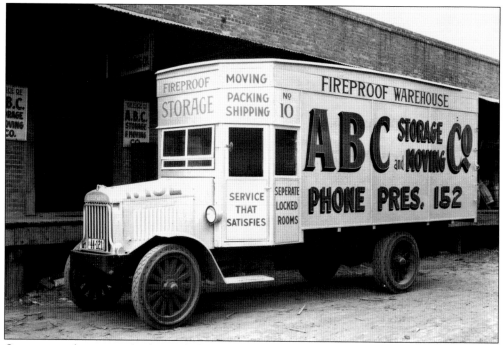

Once a new home was built, a reliable truck to move one's home furnishings was needed. This 1926 ABC Storage and Moving truck was parked in front of its 2501 Commerce Street warehouse location.

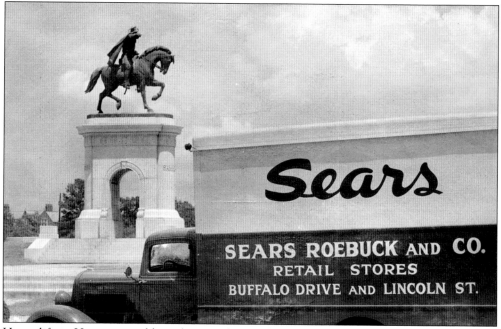

Home life in Houston would not be complete without a Sears store. This delivery truck was photographed in Hermann Park near the Sam Houston Statue. The Sears Buffalo Drive location would turn out to be a flood liability in 1935 because of its proximity to Buffalo Bayou. The store was moved to Main Street just south of downtown.

Three

WORKING FOR A LIVING

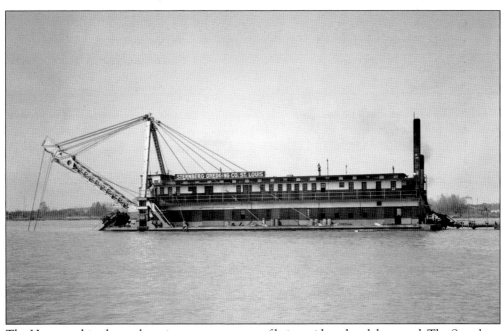

The Houston ship channel was in a constant state of being widened and deepened. The Sternberg Dredging Company from St. Louis was working in the channel off of Morgan's Point in the 1930s to make way for larger ship traffic.

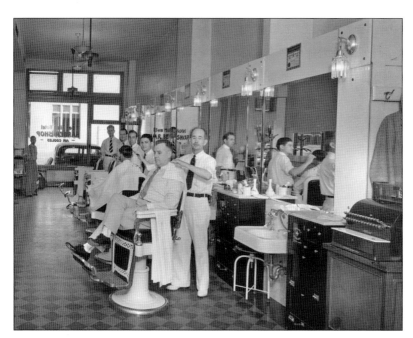

The Ben Milam hotel barbershop was located across the street from Union Station. This 1935 photograph shows Lester Mayes (center) giving a customer a trim.

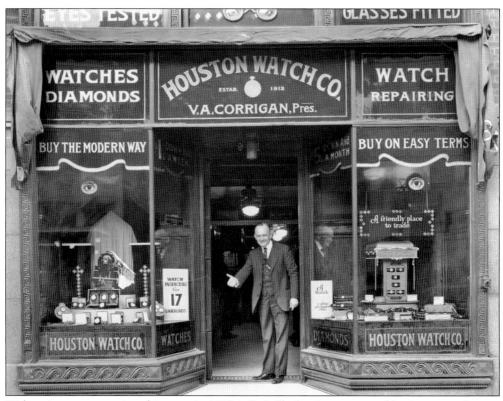

Welcoming customers into his store in 1928 is R. J. Slagle. As a respected businessman, he was elected president of the Houston Retail Jewelers Association several times. His business was located on the ground floor of the Southern Pacific Building on Franklin Avenue.

Houston had several compress companies located on or around the ship channel. In 1930, over 1,395,000 bales of cotton were warehoused at the port. Every year, the first cotton compressed into a bale was used for promotional purposes. Farmer Francisco Lozano's bale in 1935 was shipped to Europe and put on public display.

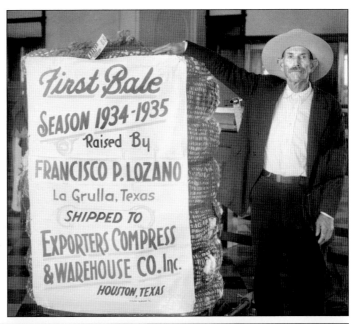

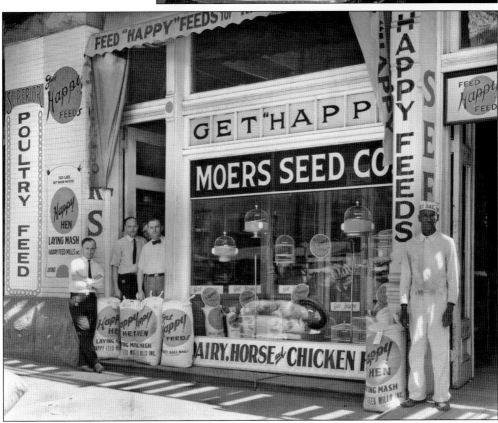

In 1932, Houston was considered a modern city; however, there was a large segment of the population who still raised their own chickens. Moers Feed Company at 613 Preston Avenue specialized in selling Happy Feeds mash for hens.

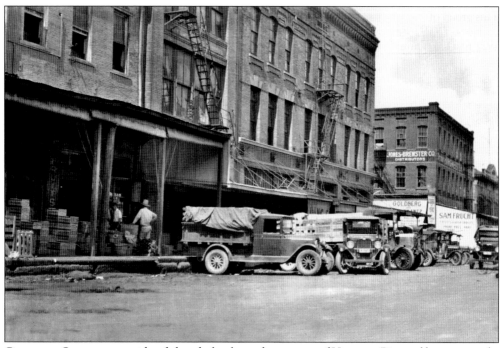

Commerce Street was considered the wholesale produce center of Houston. Pictured here are trucks backed up to the Grocers Supply Company in 1929 waiting to shuttle produce to local markets.

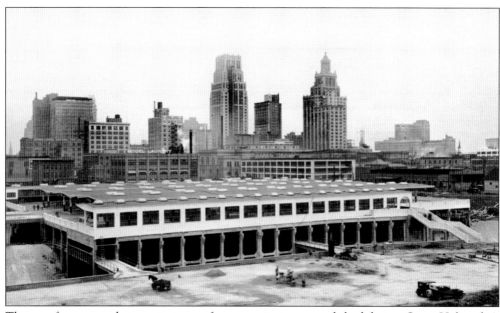

The new farmers market was just one of many projects accomplished during Oscar Holcombe's many terms as mayor. The facility stretched over Buffalo Bayou and had a magnificent skyline view of Houston.

This group of seamstresses in 1927 had to endure the heat of the day with little more than an open window. The pressing of a pleated skirt required special handling.

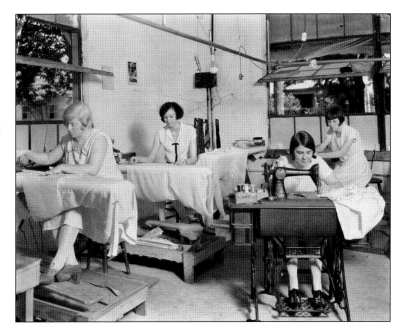

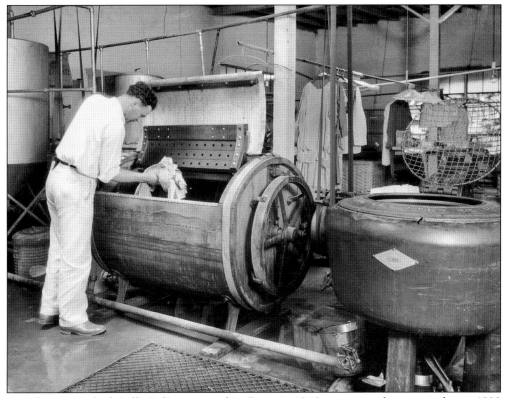

Dry-cleaning, which Jolly Belin invented in Paris in 1840, was every bit as popular in 1930 Houston. This employee of the Model Laundry Company places a garment in a machine designed to extract the dry-cleaning chemicals.

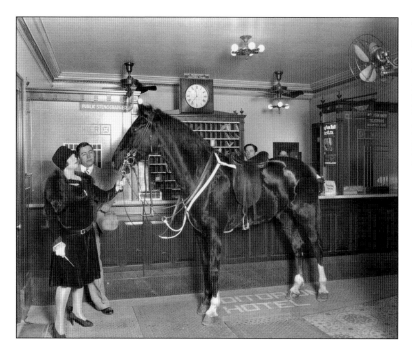

Working the front desk at the Auditorium Hotel was never boring in 1927. The hotel sponsored "The Pride of Houston" trophy for a futurity race held in Galveston.

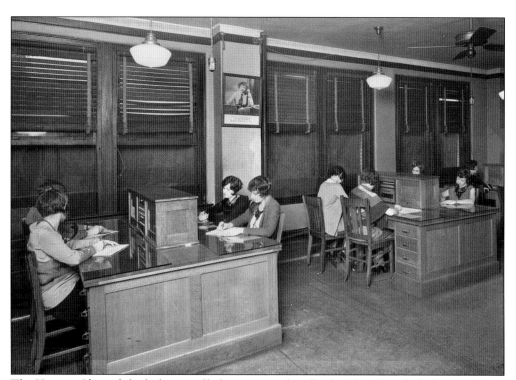

The *Houston Chronicle* had a large staff of operators to handle the Miss Classified advertisements. In 1932, Rosalie Shaw formed a Private Branch Exchange (PBX) club for private telephone operators. They met at the YWCA.

Sanitary Farms Dairy was a large operation utilizing a state-of-the-art testing facility and a well-trained sales force. When sales were down, Sanitary salesmen were told to push chocolate milk and orange juice.

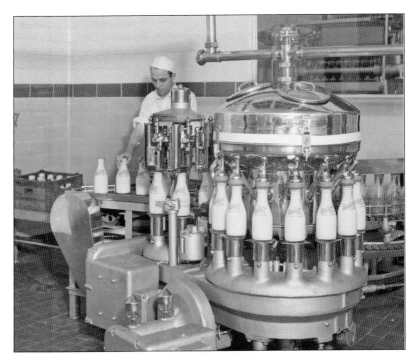

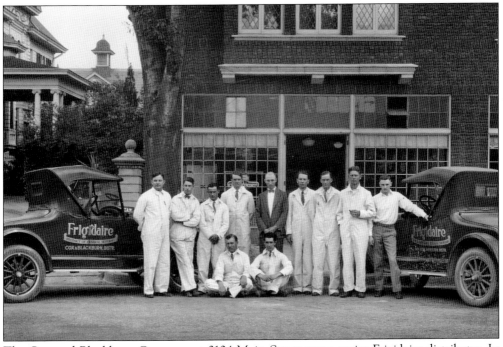

The Cox and Blackburn Company at 3104 Main Street was a major Frigidaire distributor. In 1937, over $1 million was spent air-conditioning the Rice, Texas State, Lamar, William Penn, and Sam Houston Hotels.

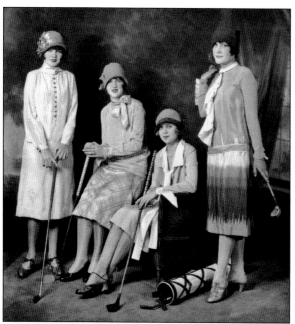

These models wearing the latest golfing fashions worked for Foley Brothers Dry Goods in 1928. The city golf course, located in Hermann Park, was built in 1922.

The JOS F. Meyer Company and machine shop at 201 Milam produced and sold a number of goods. It employed blacksmiths and wagon makers. As contractors for the railroad in 1929, the company also handled heavy hardware and automotive equipment.

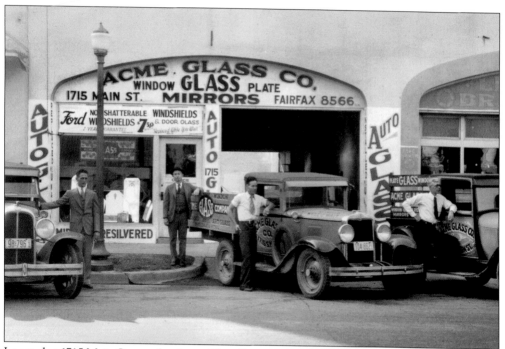

Located at 1715 Main Street, the Acme Glass Company took full advantage of Houston's growing automobile ownership by advertising a new shatterproof windshield installed for $7.50. In 1930, Houston had almost 100,000 cars on the road.

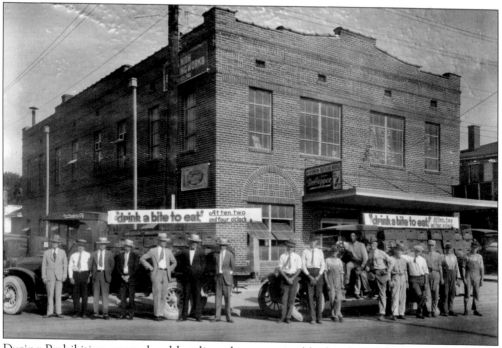

During Prohibition, many local bottling plants survived by bottling soft drinks. The Union Bottling Company and employees pose for a photograph at their 38–40 Riesner Street facility in 1928. Dr. Pepper, Delaware Punch, and Iron Brew were a few of the products they bottled.

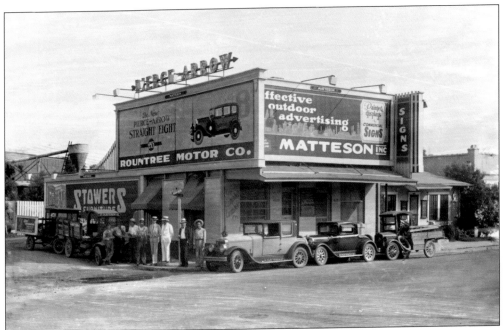

L. W. Matteson bought out Colby outdoor advertising in 1924 and Seaport painted bulletins in 1931. This gave him the distinction of being the largest outdoor painted sign company in the Southwest. Pictured here in 1929 are the employees and company office located at Main Street and Blodgett Avenue.

In 1866, the Houston Gas and Fuel Company was formed to make gas out of coal. A contract with the city to light its streets in the late 1800s increased the exposure and consequently consumer popularity of gas use. Pictured here is a 1930s gas service crew.

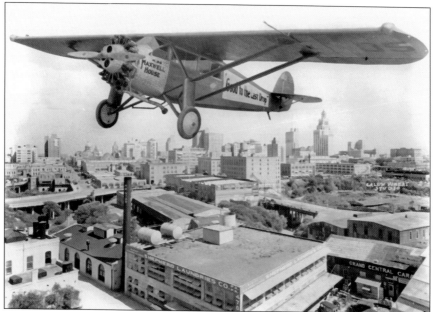

The Miss Maxwell House airplane, seen above, is a good example of early corporate advertising. This 1928 image is a manipulated negative. The airplane was photographed on the ground, and the negative was combined with a Houston skyline negative to achieve the frozen-in-time effect. The company was sold to General Foods, and the Maxwell House—"Good to the Last Drop"—brand manufactured in Houston became one of the most popular brands in the world. Pictured below is J. F. Sloan, manager of the Cheek Neal Coffee Company, receiving his new car.

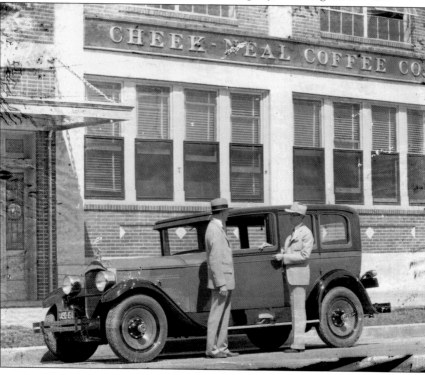

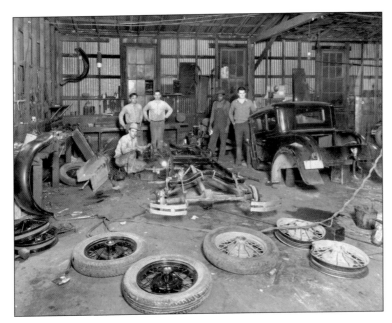

The Ford automobile manufacturing plant located in Houston assembled thousands of cars that eventually would need repair. This small shop is typical of the neighborhood garages found in 1929.

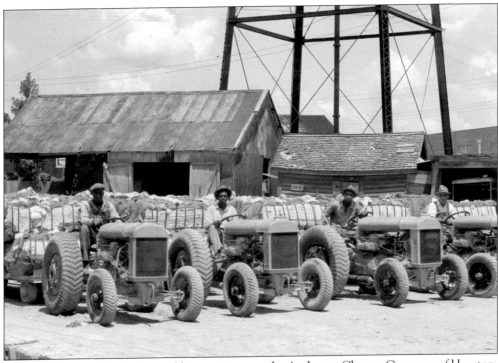

The largest cotton firm in the world at one time was the Anderson-Clayton Company of Houston, but it was not the only cotton company in town. Smaller businesses like the Terminal Compress and Warehouse Company, pictured here in 1933, shared in the Port of Houston's growth.

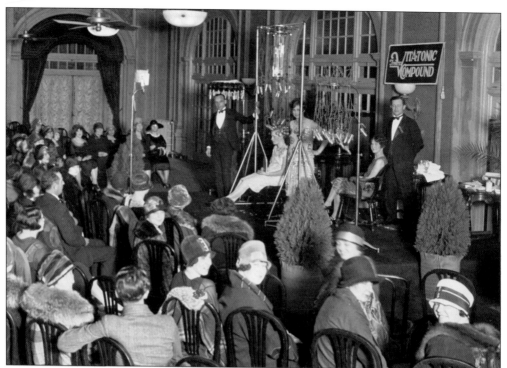

In 1928, the newest hairstyle was the permanent wave. This elaborate Vita Tonic Compound process was demonstrated in the ballroom of the Rice Hotel.

The photographers and staff of Calvin Wheat's studio had the reputation of working hard and playing harder. Calvin (first row, far left) left Houston for Kansas City in the late 1920s to ride out the Depression.

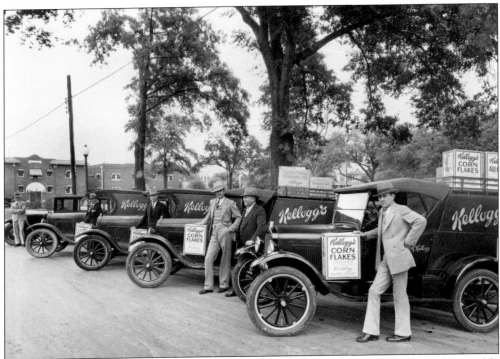

The Kellogg's Company started in 1906, and this fleet of salesmen in 1928 looks ready to tackle the 70-plus square miles of local Houston territory.

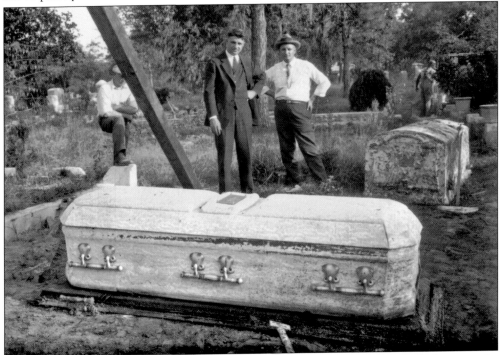

This photograph made in 1930 shows the exhumation of a coffin at Forrest Park Cemetery for interment in a new mausoleum.

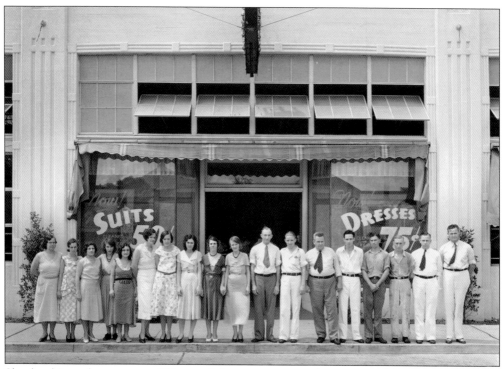

Shepherd Laundry was one of Houston's largest commercial operations. The location pictured here in 1927 was razed to make way for the new train station in 1930. Like many of Houston businesses during this period, Shepherd Laundry was segregated. While black and white employees may have worked together, their company pictures were taken separately.

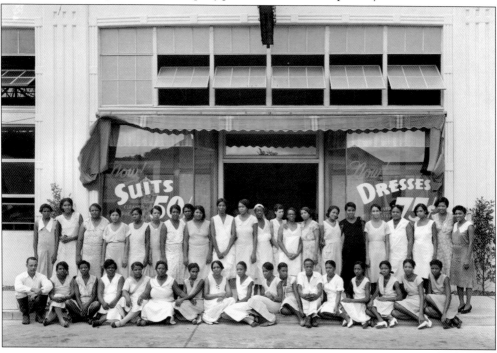

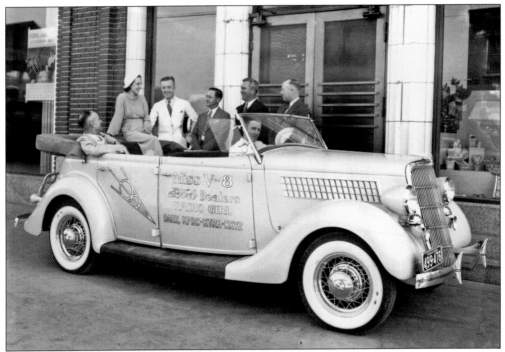

The Ford Motor Company had an assembly plant located on 3906 Harrisburg Road, seen below. In 1928, the company was having an open house week for local Houston Ford dealers. Houston had six major Ford dealers (Raymond Pearson, Davis Motors, Bonner Motors, Garret Motors, Johnston Motors, and Jack Roach) who cooperated on promotional events like their radio specials. All six are pictured above with their Beauty Queen radio girl.

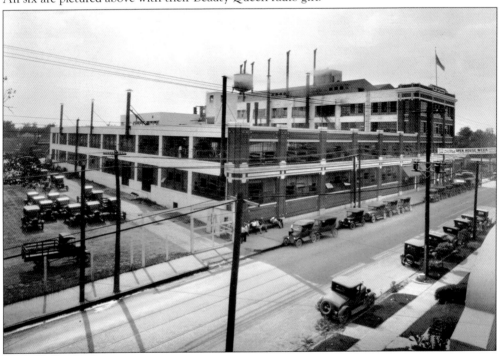

Four

HOUSTONIANS AT PLAY

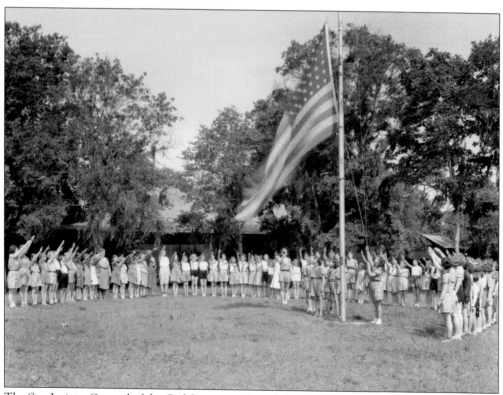

The San Jacinto Council of the Girl Scouts was founded in 1922 by Corinne Fonde and Mrs. F. M. Law. This patriotic photograph was made in the 1930s at the Girl Scout camp south of Houston in Clear Lake. The summer camp offered clean cabins plus archery and swim safety lessons.

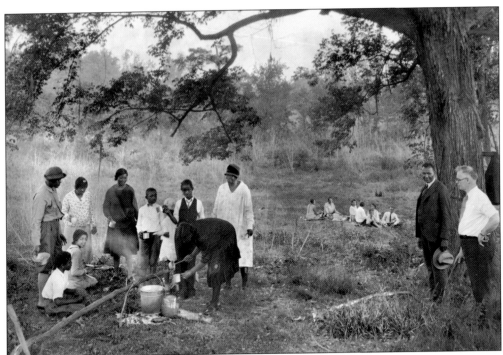

These two outdoor events are good examples of how white and black Houstonians recreated separately outside in the local environment. The black picnic above was held near the banks of Buffalo Bayou in 1929. Their clothes indicate perhaps an after-church event. The Italian festival in the photograph below was around the same time period. The park location is unidentified. Houston's first city park, Sam Houston, opened in 1900.

Galveston Island was the perfect location for this Houston Exchange Club hot dog cookout on the beach in 1927. The formal attire of one cook was customary for some beachgoers.

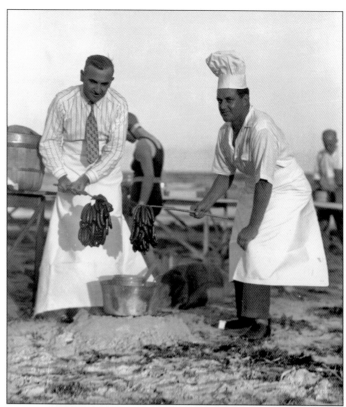

In 1932, Sylvan Beach offered multiple amusements for Houston patrons. The park was located just a short drive east of downtown in La Porte off of Galveston Bay. This kiddie car ride was adjacent to the DODGEM electric bumper car rink. The adult parking lot could accommodate 2,000 automobiles.

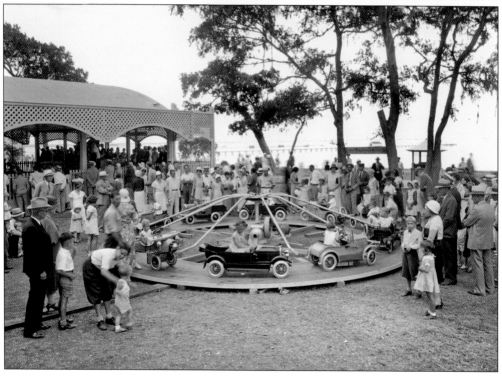

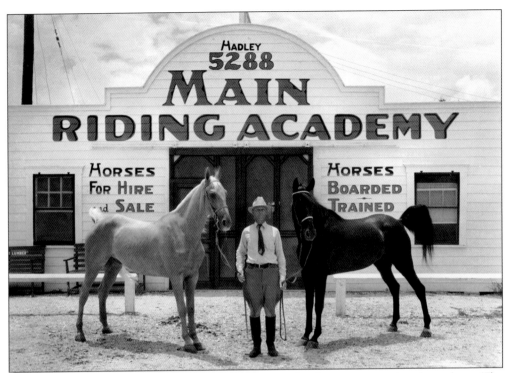

In 1933, there were several riding academies in Houston for the novice to serious horse lover. The Main Riding Academy was located on Main Street at the Bellaire Boulevard intersection. They also had stables for rent for those who owned their own horse.

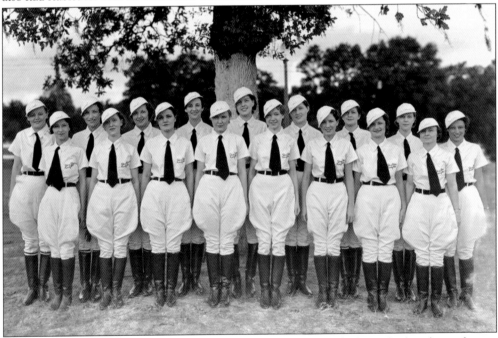

The Chevy Chase Riding Club was a private organization, and very little can be found regarding its origins. This 1933 photograph indicates that it was comprised of many well-dressed members.

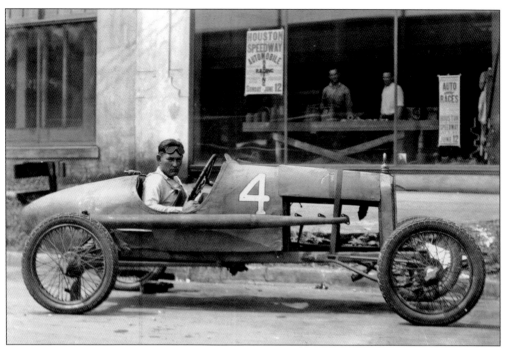

The Houston Speedway was located south of Houston off of Bellaire Road a little more than a mile west of the end of Main Street. This driver in 1927 (above) would have a hard time getting to the finish line without an engine. It was not uncommon to pit plane against car in the 1920s. In 1937, the Houston Speedway was home to the first midget auto race held in Texas. It drew over 9,000 spectators.

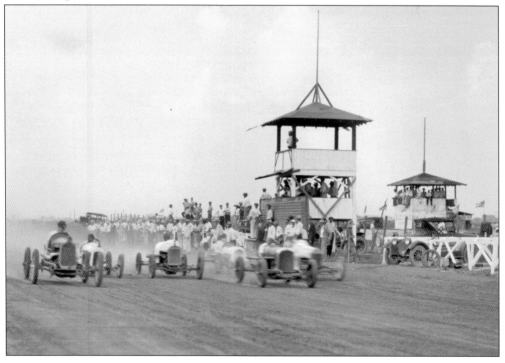

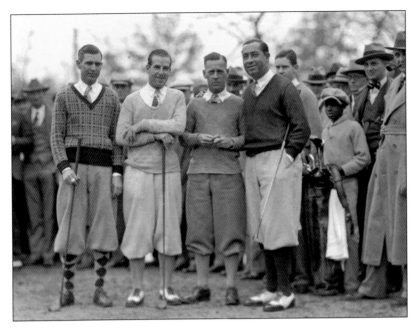

Just west of Houston was the new River Oaks Country Club Estates. It featured a first-class golf course, and golfing great Walter Hagen (second from right) played there in the 1920s.

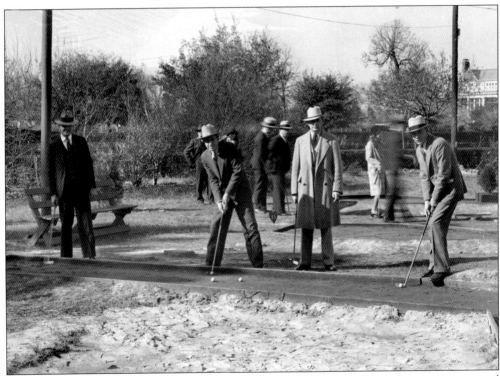

One of the fads that caught on in 1930 was miniature golf. Over 40 building permits were granted that year in Houston. The Lilliputian miniature golf course pictured here was located near Hermann Park. The municipal course in Hermann Park saw over 60,000 golfers in 1929.

C. L. Bering (left) owned Bering Sporting Goods at 709 Travis Street. He was a big sporting enthusiast and would feature customers' hunting spoils in front of his store. This 1927 stringer of 15 prairie chickens was bagged by Peg Melton.

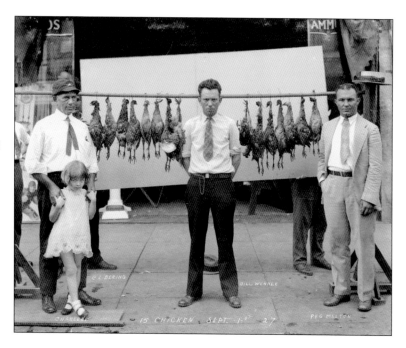

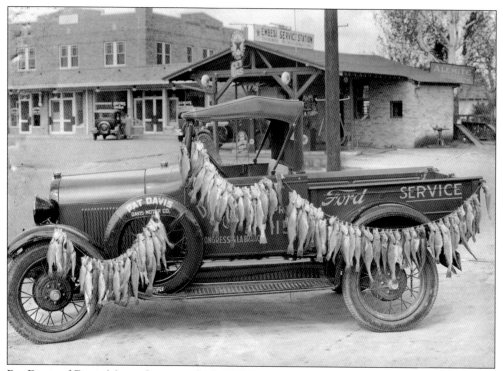

Pat Davis of Davis Motor Company had a fishing camp off of Chocolate Bayou. Fishing must have been good because his 1928 company service truck was used to display this outstanding stringer of speckled trout. The photograph was made in the parking lot of a local icehouse on Westheimer Road.

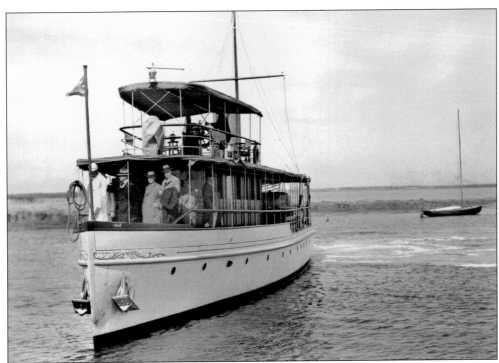

In 1911, C. G. Pillot commissioned local shipbuilder William Nelson to construct him a new motor yacht, the *Augusta*. Pictured here in 1936, it was completed in 1912 with a length of 103 feet.

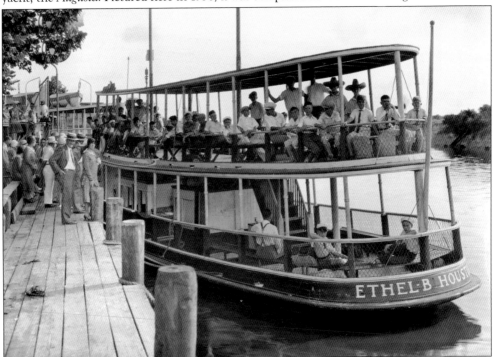

The *Ethel B* was one of several ferryboats available for hire. Shown here in 1927 at the Harrisburg docks, the boat was loaded with boys on their way to Camp Sterling.

In March 1930, the New York Yankees and Babe Ruth came to Houston to play an exhibition game with the Houston Buffaloes. It was a sparse crowd of only 3,000 onlookers as the Yankees crushed the Buffaloes 17-2. After the game, Babe Ruth gave a talk at the Houston City auditorium to the Knot Hole Gang boys. This organization was formed to pay for the admission to baseball games of underprivileged children who could normally not afford the price of a ticket. It was sponsored locally by the Kiwanis Club. Appearing with Babe Ruth on stage is the Houston Buffaloes and Houston Baseball Association president, Fred Ankenman (far left). Pictured below is a good shot of all the boys who were in attendance.

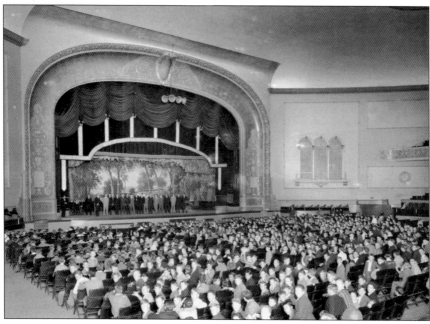

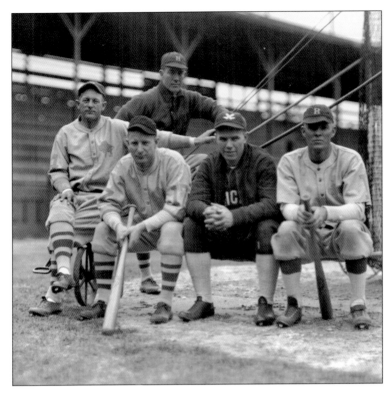

This group of Houston Buffaloes in 1929 is taking a break from batting practice at Buff Stadium. The Buffaloes were the farm club for the St. Louis Cardinals. The ballpark was located on Calhoun Avenue and St. Bernard Street.

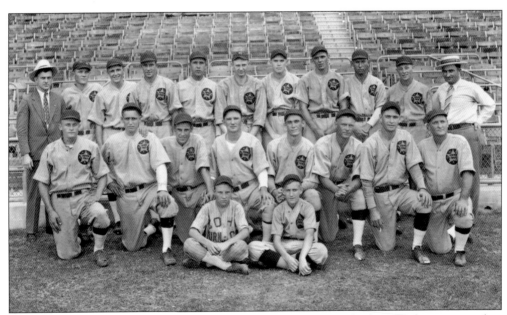

Baseball was big in Houston, and many of the larger companies had teams that competed in Houston's City Industrial League. Pictured here in 1932 at Buff Stadium is the Houston Lighting and Power team. They were the Industrial League champions in 1930.

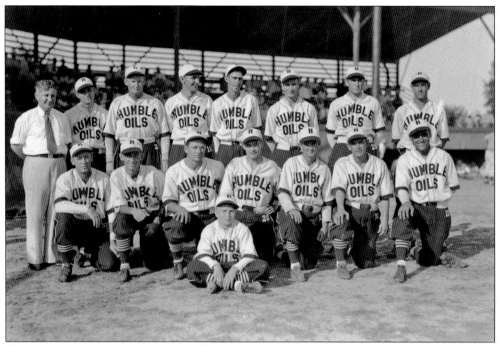

The Humble Oil Company was one of Houston's biggest petroleum businesses; now as Exxon, it is one of the largest in the world. Pictured here is their company team in 1931.

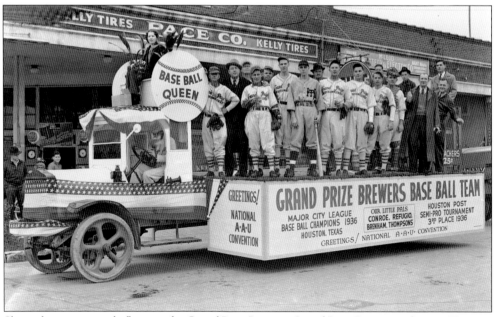

Shown here on a parade float are the Grand Prize Brewers. Grand Prize Beer was a favorite Houston beverage, and the company team in 1936 was the Major City League baseball champions.

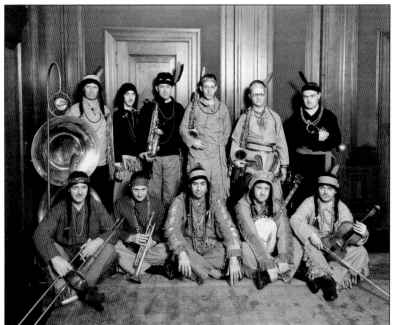

One of Houston's local industries was the American Made Flour Company. Their large plant cost $1 million to build in 1923. In 1932, it cost them $200,000 a year just to power it up. They also had an advertising budget of $250,000, of which a portion was used to sponsor their radio band, pictured here.

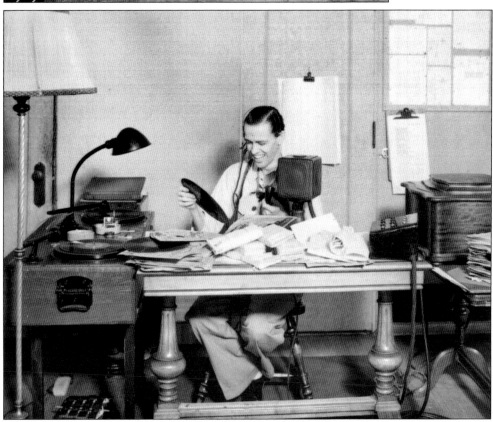

In 1930, Houston had four radio stations. This is popular radio host Guy Savage at the KTRH mike. The radio station gave its first broadcast at the Rice Hotel on March 25, 1930.

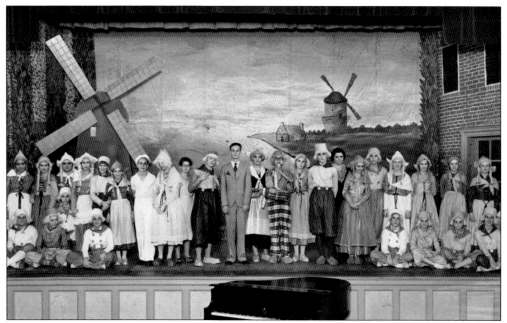

For those Houstonians with families, a night on the town might entail the viewing of a school play. The students of Sidney Lanier School in 1931 are performing the play *The Windmills of Holland*.

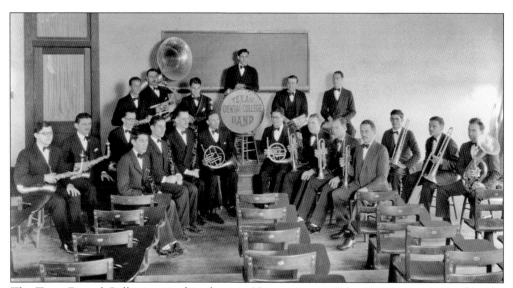

The Texas Dental College opened its doors in Houston in 1905. In 1943, it was acquired by the University of Texas. Pictured here is their 1927 college band.

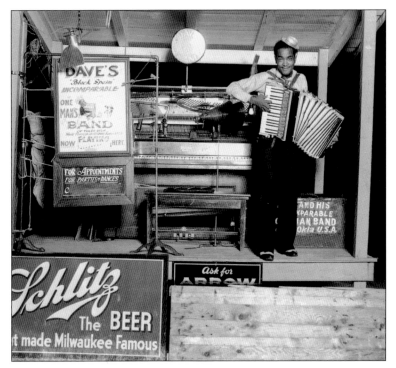

One of Houston's many traveling performers was Dave's Black Spasm Incomparable One Mans Band from Tulsa, Oklahoma. In 1933, he was performing at Weber's Beer Garden, located at Main Street and Bellaire Road.

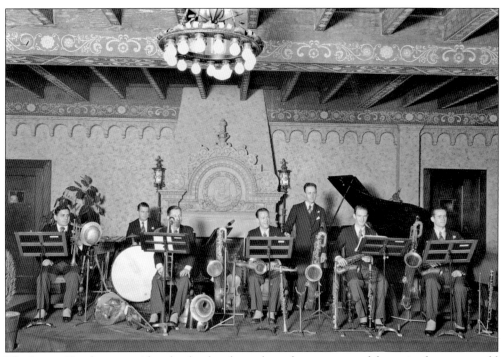

The Lamar Hotel was considered to be the place where the most powerful men in the state would meet to conduct personal and political business. Like most large hotels in town, it had its own band and ballroom. Here the band is posing for a 1928 group shot.

The Gene Lewis Players performed in the 1920s at the Palace Theatre, located at 807–811 Texas Avenue. Two of the performers photographed here were appearing in the play *Pierre of the Plains*. Hollywood legend Clark Gable got his start with this group.

The Weaver Brothers and Elviry were a popular vaudeville act from the Ozarks. Their musical talents included playing the saw on stage. Local Ford dealer Pat Davis sponsored their appearance in the 1930s.

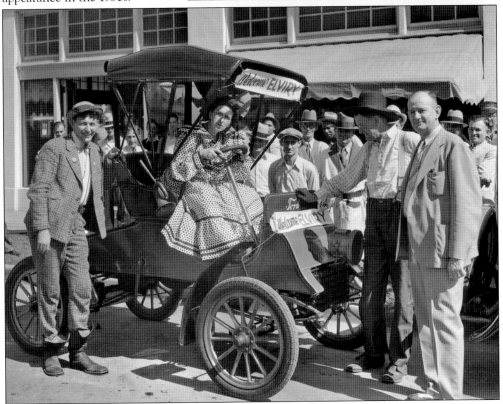

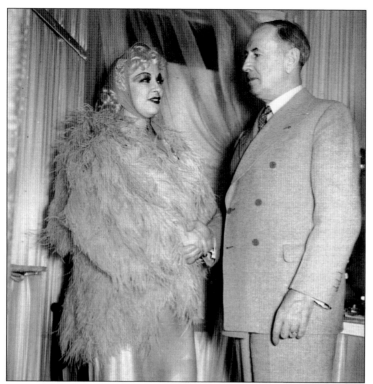

The best stars from Hollywood came to Houston promoting their films. In April 1937, the sultry Mae "why don't you come up and see me sometime" West was in town and performed at the Metropolitan Theatre on Main Street.

The grandest of all Houston movie palaces was the Majestic on Rusk Avenue. Pictured here in the 1920s is one of the theater's public events to draw traffic. The man would hang upside down and write the Pledge of Allegiance backward on the big chalkboard.

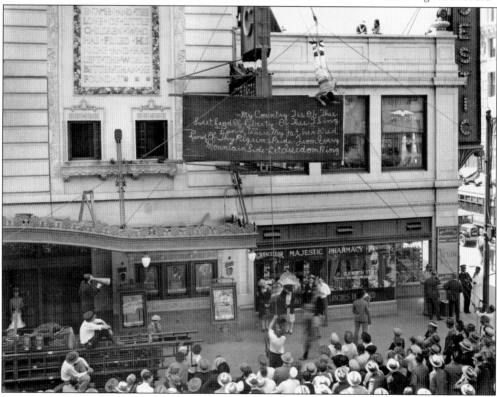

The Lincoln Theatre was located at 711 Prairie Avenue and managed by O. P. DeWalt. It was the first black-owned and -operated movie theater in the city of Houston. It offered films and vaudeville acts and was the occasional meeting place for the Ancient Order of Pilgrims. The manager, O. P. DeWalt, was shot and killed at the Lincoln in 1931.

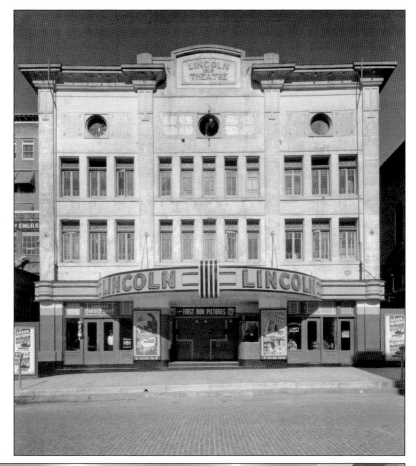

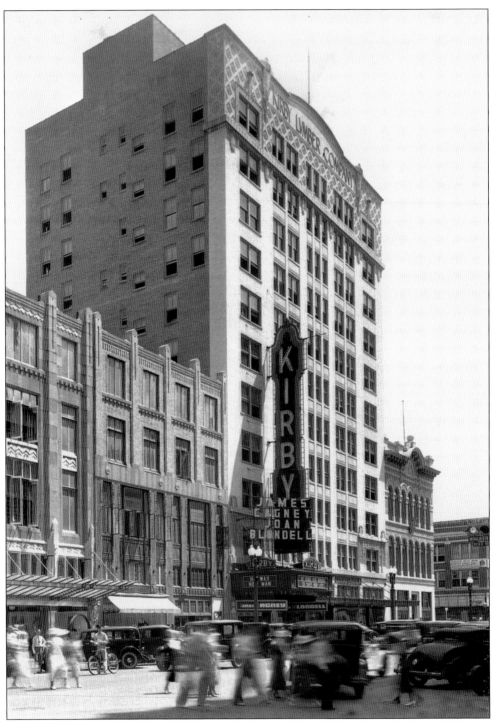

The Kirby Theatre and Building was located on the east side of Main Street between Walker and McKinney Avenues. The building was constructed in 1927 by local timber tycoon John Kirby. It had the distinction of being the first movie theater in Houston to present a featured talking film, *The Jazz Singer*. Here, in 1934, the theater is playing *He Was Her Man*.

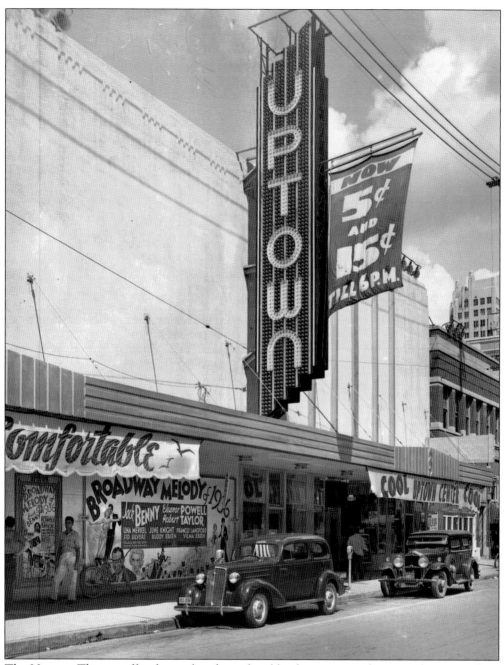

The Uptown Theatre offered a cool and comfortable place to view the new release *Broadway Melody of 1936*. It was built in 1935 by Will Horwitz and located at 805 Capital Avenue. The price for a movie started at a nickel for early-afternoon shows.

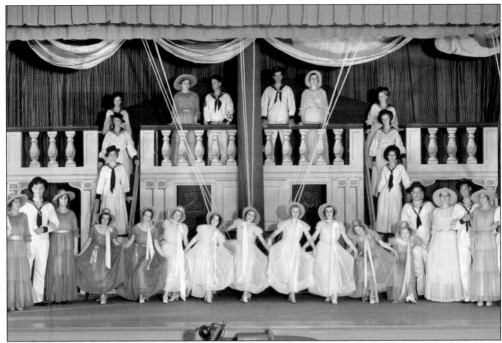

The Houston Little Theatre was organized in 1925. In the 1930s, the company moved from its 808 Anita Avenue location to a brand-new facility at 707 Chelsea Boulevard. The growth was attributed to then director Frederick Webster. The 1931 season opened with *The Road to Rome*. The theater also held a benefit performance to help the mayor's fund for the unemployed. Pictured here are the exterior of the new location on Chelsea (below) and a scene from a 1932 play held there (above). One of the theater's most famous actors was Nina Vance, the founder and artistic director for the Alley Theatre.

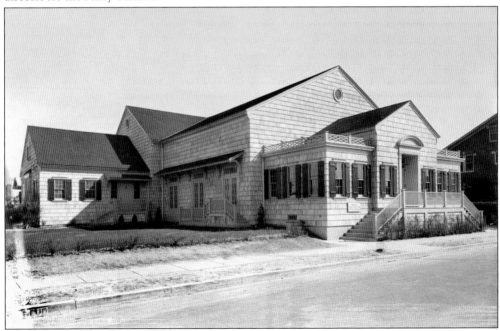

The Hallie Pritchard School of Dancing was located at 1006½ Rusk Avenue. Pritchard was considered the premier dance instructor in Houston for decades. Pictured here is a 1930s dance class.

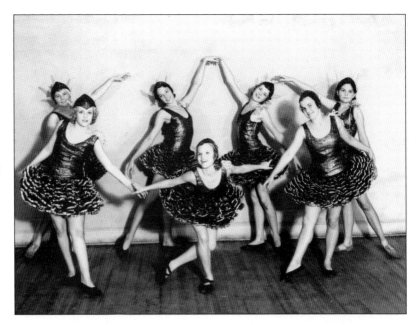

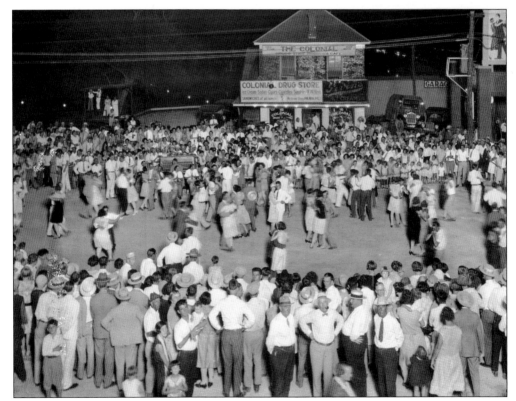

One of the oldest communities in Texas was Harrisburg, just a few miles east of Houston. The Colonial Drug store would sponsor street dances in the 1920s that would draw people from Houston and beyond.

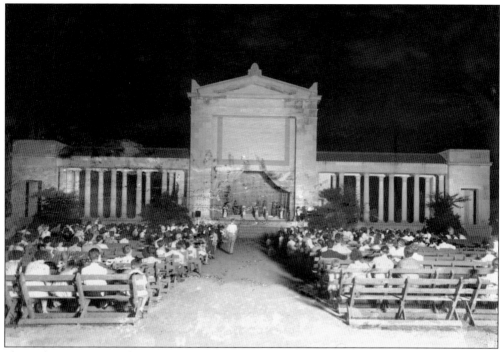

Shown here is a rare nighttime performance at the Miller Memorial Theatre in Hermann Park. The theater and the golf course both opened in 1922.

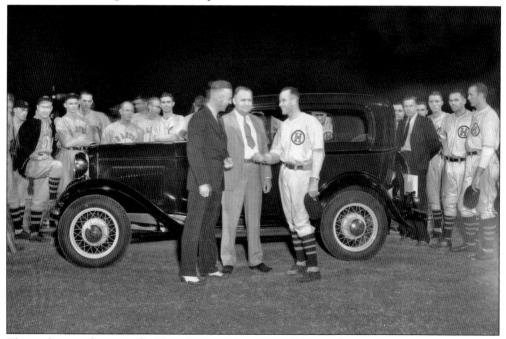

This night game between the Texas League Houston Buffaloes and San Antonio Missions was the perfect opportunity for Jack Roach Ford to give away a new car. Night games played in the 1930s encouraged the belief that hens would lay more eggs if roosting next to Buff Stadium because of the increased illumination.

Five

COMMUNITY LIFE

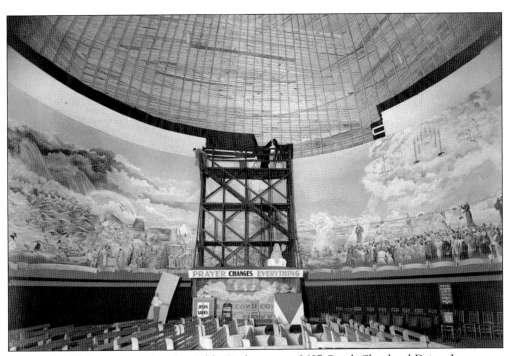

In 1936, Mel Morris opened up his Bible Cyclorama at 2637 South Shepherd Drive. It was one of the most unique church structures in Houston. The domed building's interior contained continuous religious murals on its walls and ceiling. The cyclorama was open for tours every day except Mondays. The doors opened at 3:45 p.m. with no admittance after 4:00 p.m. People had 15 minutes to gain entry, and then the doors were locked.

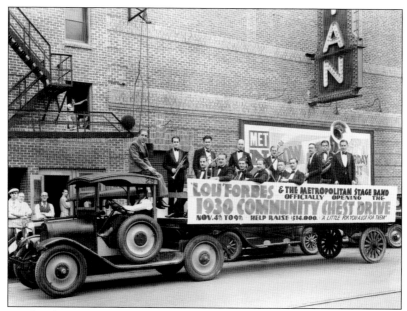

Just one year after the great market crash brought the beginning of the Great Depression, Houston's chamber of commerce and the Community Chest (United Way) set $514,000 as a fund-raising goal. Starting November 1930, H. Saford of the Missouri Pacific Rail Lines and 500 volunteers set out to accomplish that goal. Pictured above is Lou Forbes (sitting on top of the truck cab), the conductor of the Metropolitan Theatre stage band, kicking the drive off. The Community Chest was responsible for helping 32 different area agencies in Houston. The Depelchin Faith Home orphanage was one of the organizations that received funds from the Community Chest. Pictured below is a group of orphans at 2710 Albany Street experiencing the thrill of riding in a brand-new 1935 Ford.

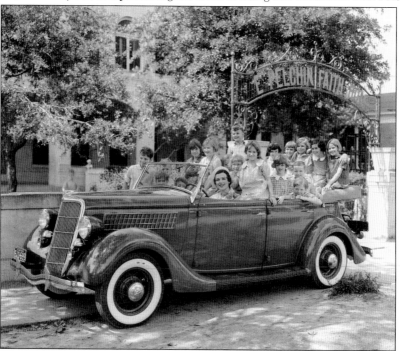

In 1930, the Cynthia Gray Milk Fund Group was formed to help stem the tide of tuberculosis. Mrs. Edward Hodges and Dr. Elva Wright realized there was a need in the community for better nutrition, and they pledged every cent raised would go to feed the needy babies and children of Houston. The organization sold tickets to sporting events and had street musicians working the crowd for donations. Pictured below is a Christmas party at the Houston City Auditorium for Houston's underprivileged children sponsored by the *Houston Press* and the Milk Fund Group.

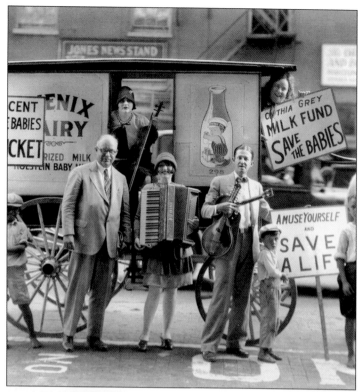

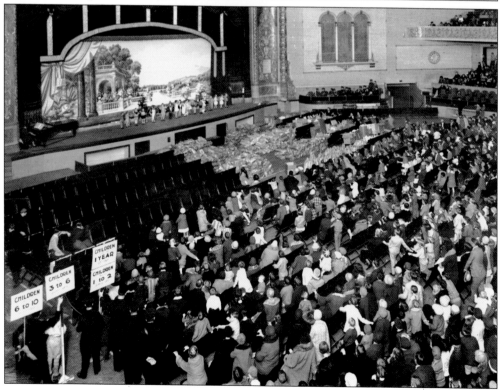

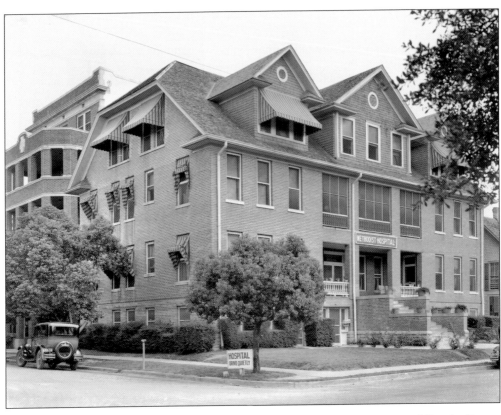

The Methodist Hospital opened in 1923 on the corner of San Jacinto Avenue and Rosalie Street. Originally a gift from Dr. Oscar Norsworthy to the Texas Methodist Conference, the hospital had 35 rooms with an additional 125 beds added later. Pictured above in 1928 is the sign in front of the hospital that asks motorists to "Drive Quietly." Below, standing in front of the Blue Birds' first home at 1606 Main Street in 1928, is a large group of members. The Blue Bird organization was aligned with First Methodist Church, and they spearheaded varies fund-raising drives for Methodist Hospital.

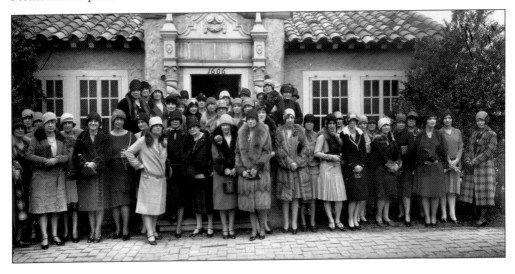

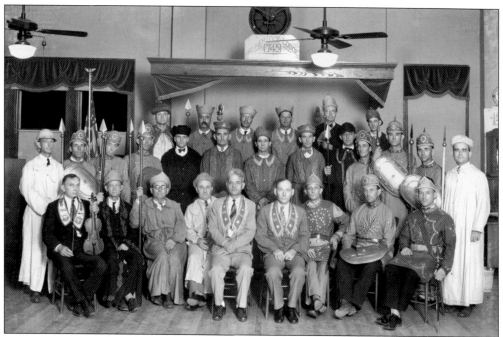

The International Order of the Odd Fellows was a worldwide fraternal organization. The first lodge opened in Houston in 1838 and over the years grew in numbers and influential members, such as local business leader Jesse Jones. Pictured are the members of Bruner Lodge 745 in the late 1920s. The Lodge was located at 4721 Center Street.

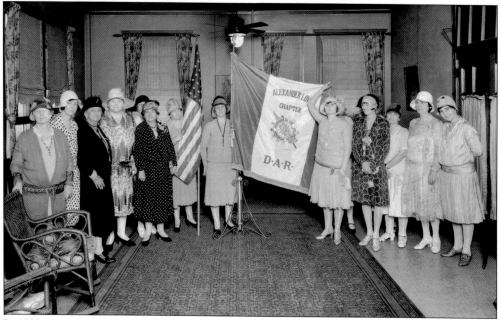

In 1923, seventy-two women stood up and became members of the new Alexander Love Chapter of the Daughters of the American Revolution. Mrs. McFarland and Mrs. Rowan were the cofounders. Their first days of service were directed to the hospital at Camp Logan for disabled veterans. This photograph is of a group meeting in 1929 held at the Rice Hotel.

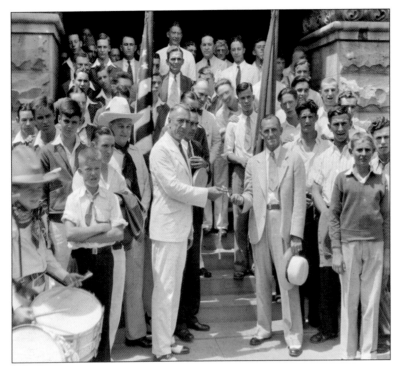

The Harris County Courthouse was the backdrop for numerous public events and ceremonies. This grouping of men and boys in 1930 was commemorating All Male Day.

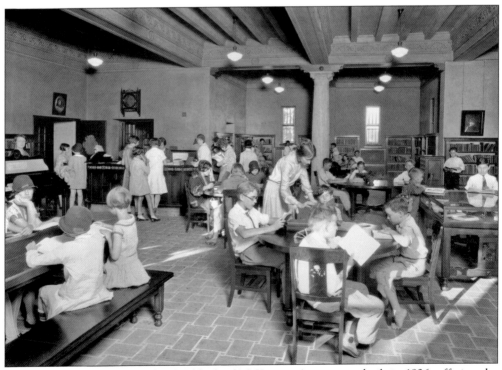

The Julia Ideson Library in the 500 block of McKinney Avenue was built in 1926, offering the citizens of Houston a first-class educational facility. Pictured here is the Children's Reading Room in 1928.

The Ancient Order of Pilgrims was a black fraternal organization. It was established in Houston in 1882 as a vehicle to help the economic situation of Houston's black community. It was located at the corner of West Dallas Avenue and Bagby Street. This rare 1928 photograph is considered to be the only known image of the building from street level.

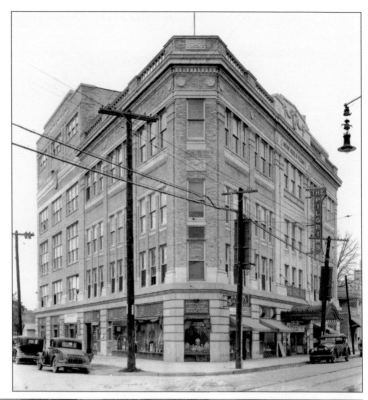

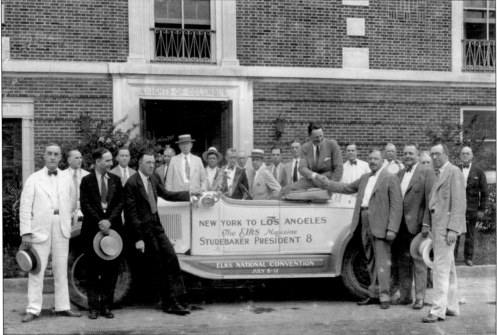

As far back as 1890, the Elks have been active in Houston. As a promotion of their annual national convention, a group of Elks drove a Studebaker around the country on a goodwill tour. This photograph of Houston Elks was made in 1929.

Pictured here on Travis Street in 1927 are Houston mayor Oscar ("the Silver Fox") Holcombe (far right) and city council members. They were promoting public transportation.

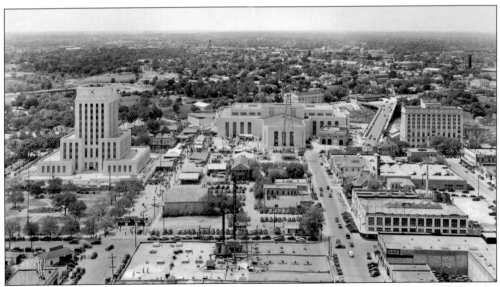

The end of the 1930s was near and the new city hall (left) was still under construction, but the Sam Houston Coliseum (center) was open for business, featuring an Oil World Convention.

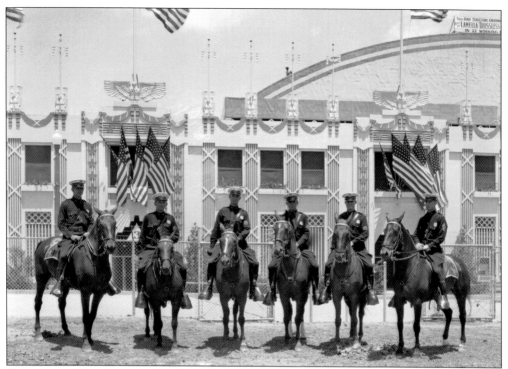

Houston could not be considered a frontier town without the presence of law enforcement on horseback. Pictured here in front of Sam Houston Hall (the home of the 1928 Democratic National Convention) are Houston's finest mounted officers.

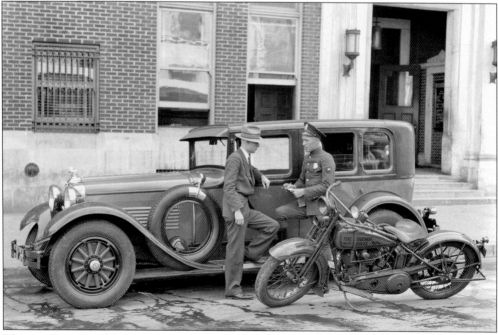

This gentleman and his expensive Stutz automobile are getting a ticket for parking in front of the Police Corporation Court on Caroline Street in 1929.

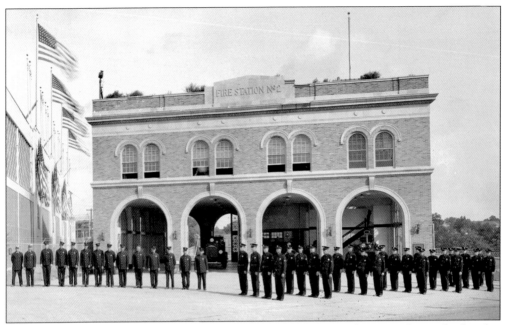

Organized in 1852, Liberty Fire Company No. 2 had many different locations. It was the first fire company to get a steam engine in Houston. Pictured here in 1928, the station was located on the corner of Capital Avenue and Bagby Street.

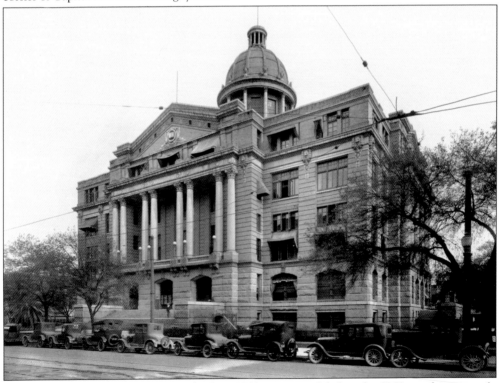

The Harris County Courthouse was built in 1910, was remodeled in the 1950s, and is currently undergoing a major restoration. This photograph was made in 1928.

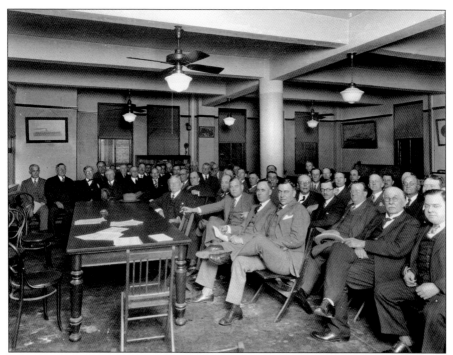

The Democratic National Convention came to town in 1928. It was held in Sam Houston Hall, and the paint was barely dry when the convention opened June 26. Despite the torrid Houston summer heat, the crowds were large inside and outside of the convention hall. Both images were made in 1928 and feature the convention entrance and the National Democratic Finance Committee.

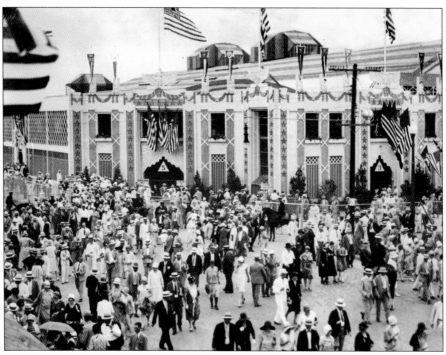

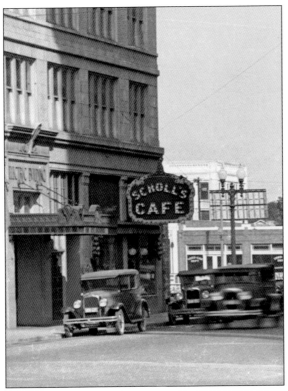

Located on the ground floor of the Houston Lighting and Power Building was one of Houston's favorite cafes, Scholl's. It opened in the 1920s and was known for its salad dressing. William Scholl would break after lunch and play mahjong with friends before the dinner crowd arrived. It supported Houston's first livestock show by purchasing meat from the event.

The Orange Grove Market offered hot meals along with fresh produce. In 1928, a hamburger cost a dime and a large T-bone steak ran 75¢.

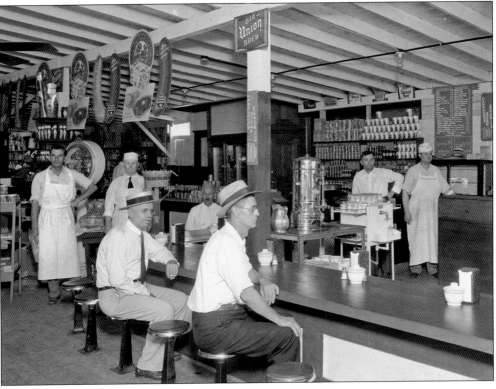

In the 1930s, Houston had a large variety of restaurants to choose from when it came time to eat. The Golden Pheasant was located at 1411 Main Street and offered a complete lunch for 50¢.

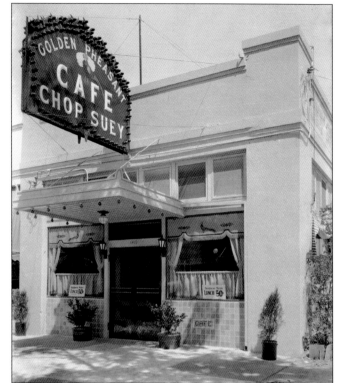

The Chateau Du Pape interior was designed to resemble a French village. Dining out was a favorite pastime of Houstonians in the 1920s, giving the hardworking housewife a break from cooking.

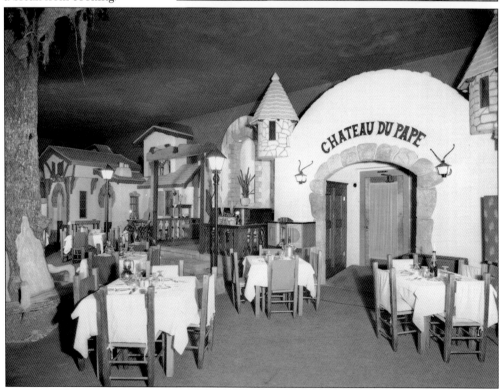

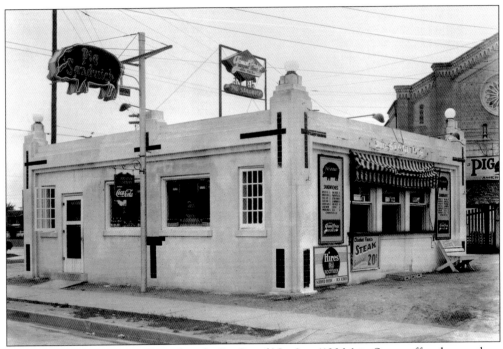

Pork was a favorite meat in Texas, but the Pig Stand No. 8 at 4120 Main Street offered more than just ham. In 1930, only 20¢ would get a person a chicken fried steak sandwich.

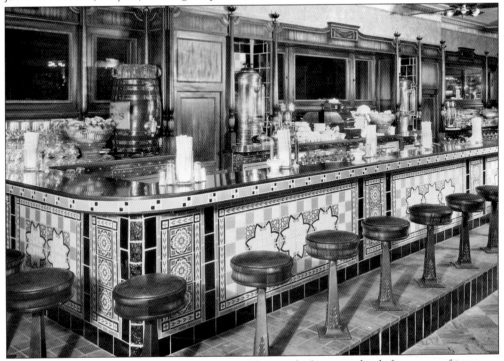

Nothing satiated Houstonians' sweet cravings like a soda fountain drink from one of its many drugstore counters. This 1932 photograph of the Rouse drugstore lunch counter illustrates the beauty of the colorful tile, polished chrome, and sparkling glass patrons enjoyed.

Six

GETTING AROUND TOWN

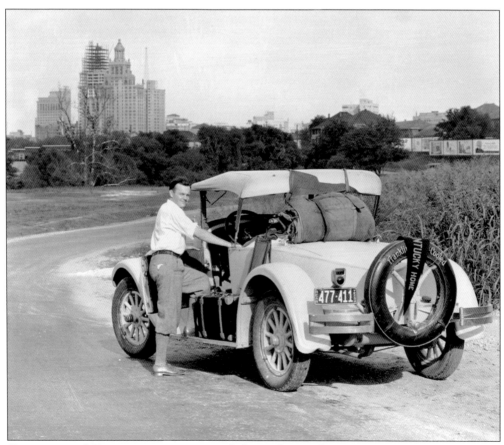

Getting around Houston was never so much fun as driving down Buffalo Drive in a brand-new 1928 air-cooled Franklin automobile.

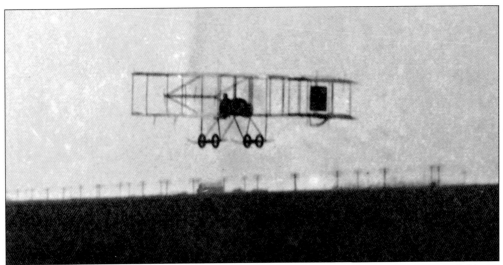

On February 18, 1910, Luis Paulhan made the first flight of an airplane in Texas in a field just south of town. The rare photograph above captures that historic flight. In the ensuing years, international air meets would come to town, fueling the desire of locals to fly. Twenty-seven years later, Eastern Airlines would extend its operation to Houston. Pictured below in 1937 is World War I flying ace and Eastern Airlines president Eddie Rickenbacker (lower center) and company officials.

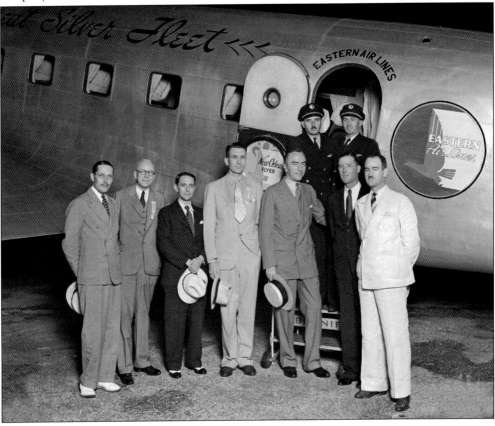

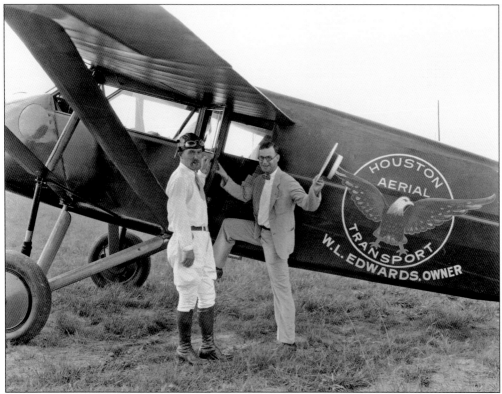

The Houston municipal airport on Telephone Road was not only known for passenger service but housed several airfreight companies. Houston Aerial Transport, owned by W. L. Edwards, represented one of the smaller businesses operating there. General Air Express and Bowen Airlines combined to offer both passenger and freight service. In 1931, $16 would buy a ticket from Houston to Dallas.

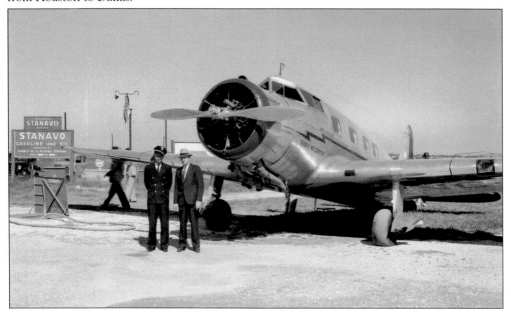

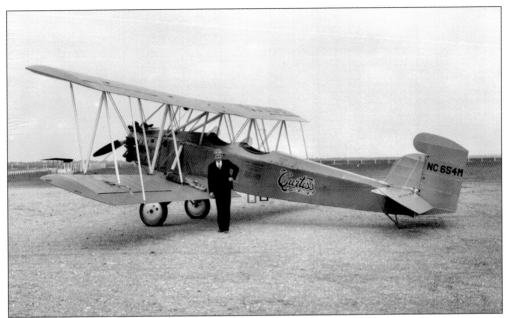

In the early days of Houston aviation, if a person wanted to learn how to fly, he or she would have to wait until a flying event or meet came to town and convince the pilots to teach a few lessons. The Curtis Flying Service instructor pictured above came complete with parachute. In later years, the company became the Curtiss Wright Flying Service, as displayed below in the 1930s at Sam Houston Hall.

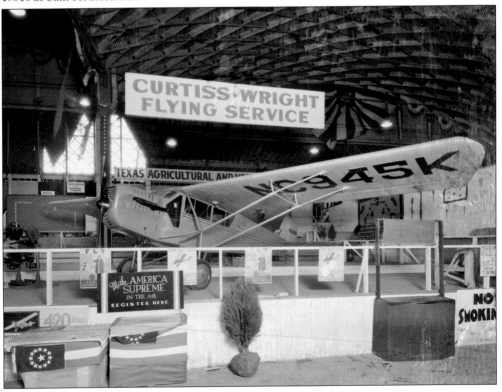

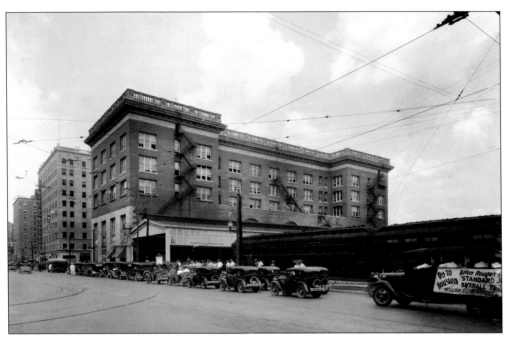

In 1928, Houston had two passenger train stations. Pictured here is Union Station, located on historic Texas Avenue. The station was built in 1911, and two additional floors were added a couple years later. It has dodged the wrecking ball over the years and was incorporated into the Houston Astros' new ballpark.

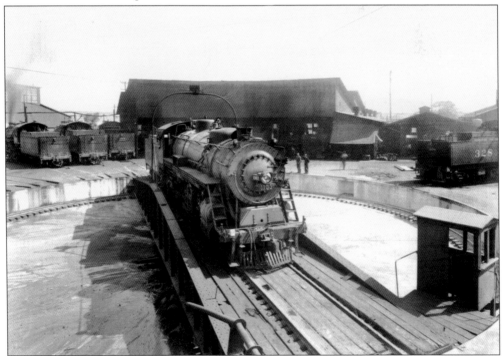

In 1929, seventy-two freight trains came in and out of Houston every 24 hours. Pictured here is the Houston Missouri Pacific freight turntable with trains waiting to be hooked up.

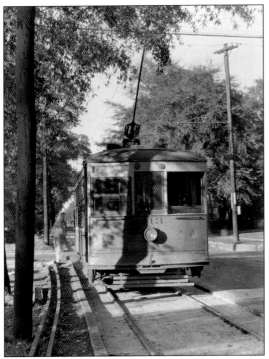

Houston at one time had an outstanding trolley system in place. In 1932, the Houston Electric Company operated 79 miles of tracks and employed 748 people. The trolley car in this photograph operated on a suburban route that was serviced by 11 trains.

The interurban operated 30 trains in and out of Houston to Galveston daily in 1930. It ran six trains in and out of Goose Creek to Houston daily. Shown here in 1934 is a trolley nearing the intersection of Travis and Texas Avenues.

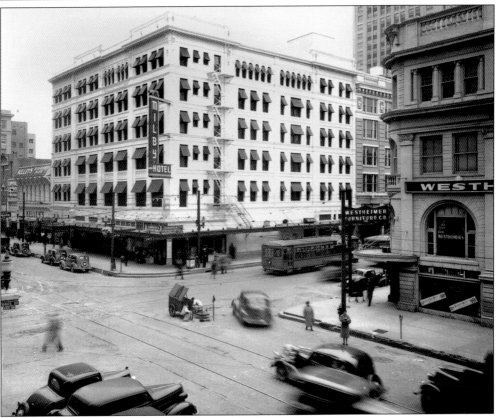

This photograph shows the Houston Bus Terminal's timetable and route information. The terminal was located at 1118 Preston Avenue. Note that under the timetable sign is the brand-new TRYET vending machine that was introduced in the late 1920s.

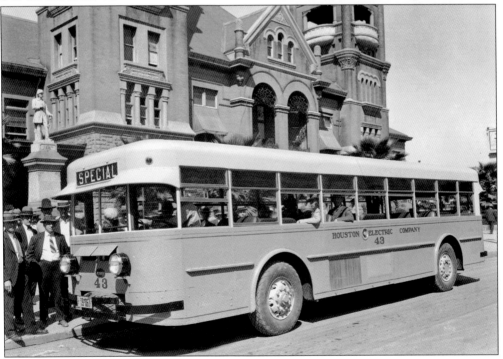

Along with the city trolley traffic, the Houston Electric Company had 119 miles of bus routes. Pictured here in 1927 is a company bus in front of city hall on Travis Street. The statue of Dick Dowling, a Confederate hero from Houston, is to the left of the bus.

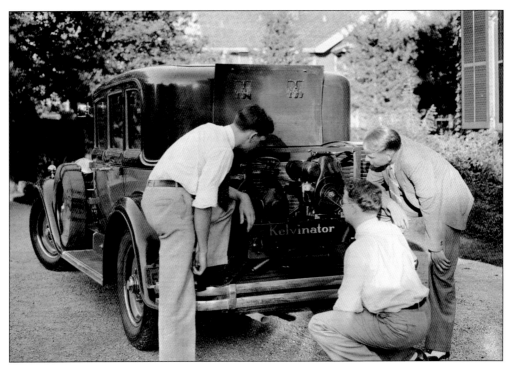

If people had to drive around Houston in the 1920s, they might as well be cool. This new Kelvinator automobile air-conditioner was one of the first in the country.

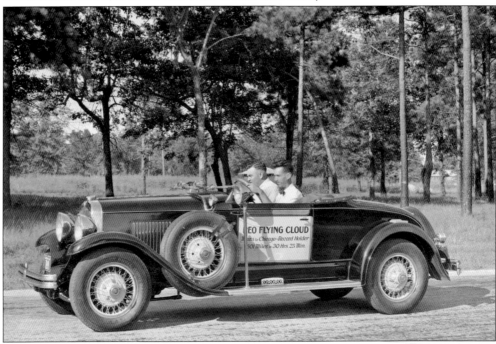

Automobile record holders of all kinds would draw crowds for local car dealers. Shown here in Hermann Park, this REO car was a record speed holder: Miami to Chicago in 30 hours and 25 minutes.

The USS *Constitution* came to Houston in 1932. This grand old warship started on a coastal tour of the United States in 1931. It was towed down the intercoastal waterway along the Atlantic and Gulf coasts. Once through the Panama Canal, it went up the West Coast to the delight of millions of Americans. Over 100,000 Houstonians toured the boat. At right, the motorboat *Broker* and its owners are about to give the historic ship's captain a tour of the channel. Pictured below is the USS *Constitution* floating past the public docks at the San Jacinto Battlefield in 1932.

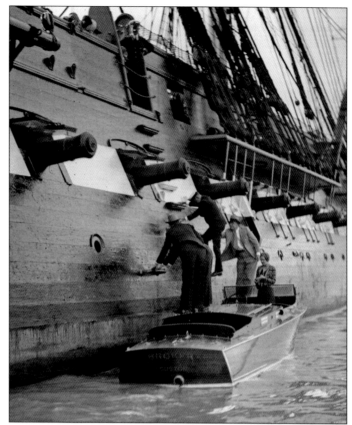

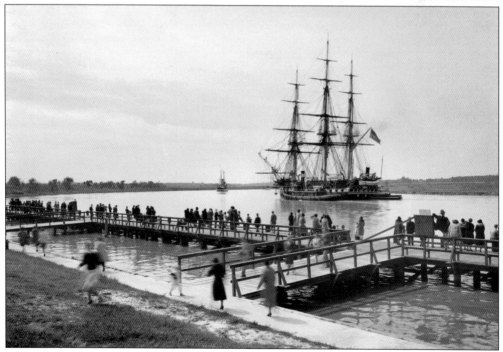

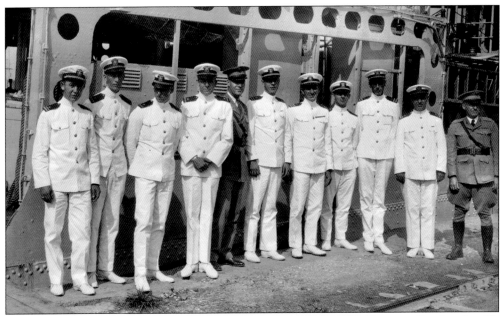

The first U.S. Navy ship to be named for a Texas city was the USS *Houston*. On October 25, 1930, around noon, the *Houston* arrived. Its appearance coincided with the Port of Houston's birthday. Texas governor Dan Moody and Houston mayor Walter Monteith were just a few of the many dignitaries on hand to greet Capt. Jesse Bishop Gay and crew. The officers were wined and dined all over town, including a parade for the public. Their many activities included a formal ball held at the Rice Hotel. The white uniforms glow in this 1930 photograph (above) of the officers of the USS *Houston* on deck. The spectators on the San Jacinto Battlefield docks (below) watch as USS *Houston* cruises by.

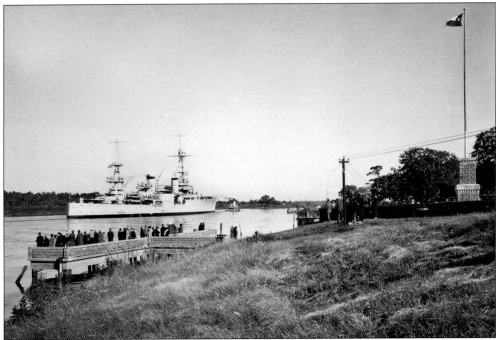

Seven

OIL

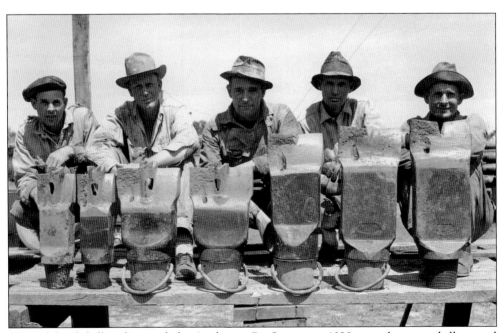

These fishtail drilling bits made by Appleman Bit Service in 1928 were the main drilling tool used before the Hughes rotary bit conquered the Texas oil fields in the 1930s.

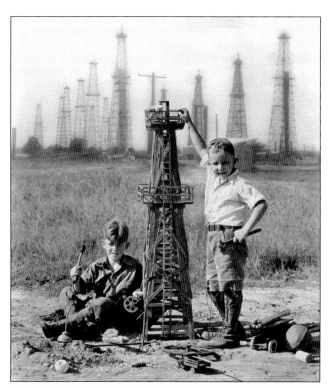

Children growing up in Houston during the 1920s had rather unique toys to play with. These two young Texas wildcatters dream of becoming the next oil barons.

Michel Halbouty and Glenn McCarthy were perhaps two of the oil industry's most influential wildcatters. Halbouty was all business and lived until he was 95. Glenn McCarthy enjoyed the Houston social scene to the extent of opening up the world-class Shamrock hotel in the 1940s. Shown here in 1928 are McCarthy (left) and Halbouty (right).

Howard Hughes was one of the most recognized Houstonians in the world. In 1938, he had just completed circling the globe, setting new records as he went. He was given a parade downtown that drew over 250,000 people. Pictured at right with Junior Chamber of Commerce president T. L. Fontaine (left) is Howard Hughes as he receives a lifetime achievement award. The 1936 rotary rock bit pictured below was manufactured at the Hughes tool plant in Houston.

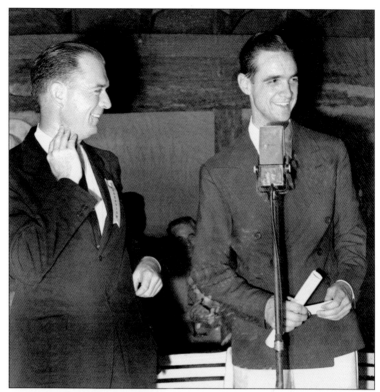

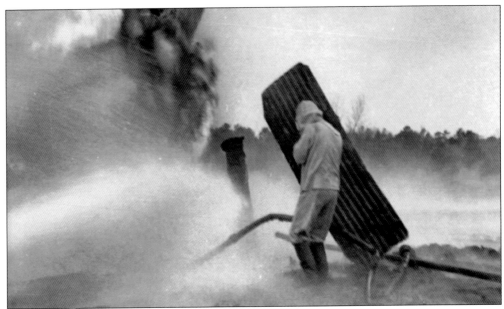

Crack open a 1935 copy of the Houston city directory, and under oil well firefighters a person will find only two names—one of them was H. L. Patton. His company held the distinct privilege of being the one to call when someone had bad trouble in the oil patch. Born just north of Houston in 1886, this local firefighting legend lost his right arm and his brother fighting oil well blowouts. The profession was very dangerous, as pictured above, yet H. L. Patton lived to be 100 years old. Pictured below is Patton with his patented manifold at the Hughes tool plant.

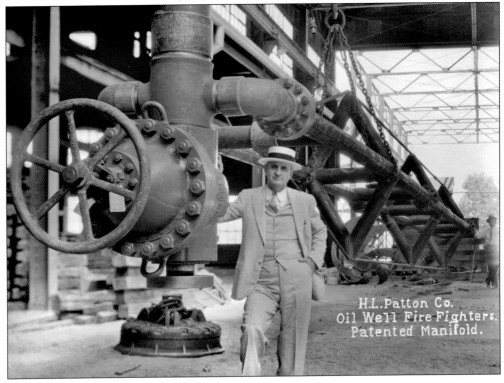

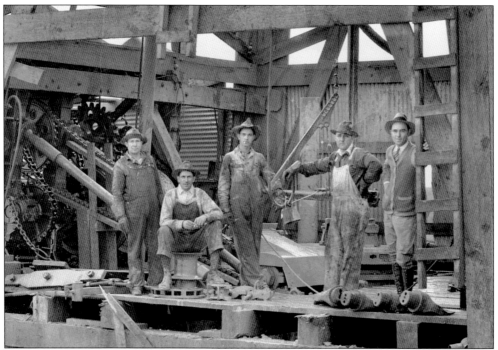

The Pierce Junction field was the closest oil field to Houston during the 1920s and 1930s. Oil was first discovered there in 1906, but it would take another 15 years before a major strike was made. Texaco founder Joseph Cullinan was one of the men who would benefit greatly drilling in the Pierce Junction field during the strike of 1921. The 1928 photograph above shows a crew of roughnecks taking a break on a Pierce Junction derrick. Note two of them are smoking! The image below is a classic example of the old wooden oil derricks used in the drilling for oil. The Pierce Junction field could be seen looking south from the rooftop of the Warwick Hotel.

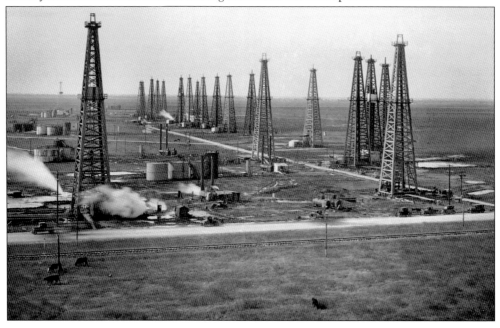

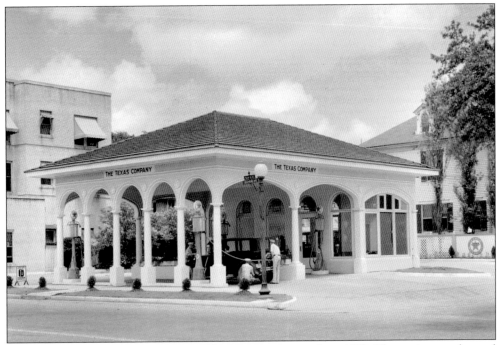

This photograph of a Texas Company filling station was made in 1928. The station was located on the corner of Main Street and Bremond Avenue. The company offices were located in the Texas Company Building on the northwest corner of San Jacinto and Rusk Avenues.

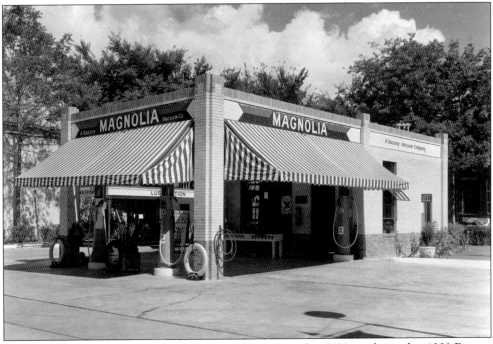

The Magnolia Petroleum Company was formed in 1911 and in 1929 was located at 1009 Fannin Street in Houston. In the mid-1920s, the stock was acquired by Standard Oil of New York. It later became Mobil in the 1950s. This 1928 station is featuring MobilGas.

Ross Sterling founded Humble Oil in 1911. In 1917, the company had over 200 wells producing almost 10,000 barrels daily. In 1930, there were eight refineries on the Houston ship channel with a total refining capacity of 194,000 barrels daily. That made for a lot of gasoline to be sold. This 1929 Houston Humble service station is offering friendly customer service to a couple of boys having problems with their football.

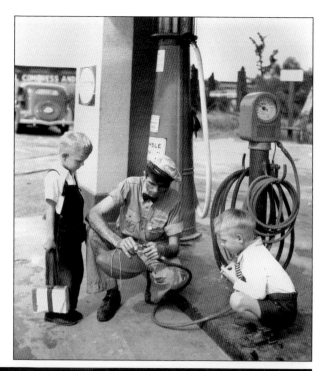

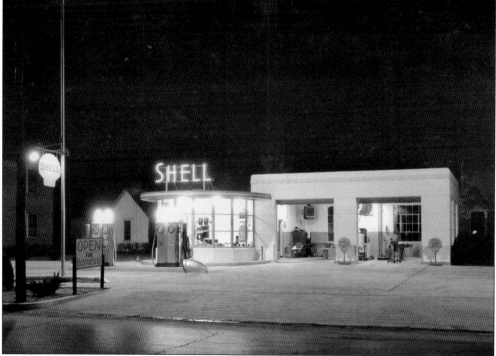

This dramatic night photograph of a Houston Shell Oil Company service station was made in 1933. In 1929, Shell Oil opened up a new refinery in Houston. In 1932, Houston had 38 oil companies headquartered in town; however, it would not be until the 1970s that Shell would relocate its corporate headquarters to Houston.

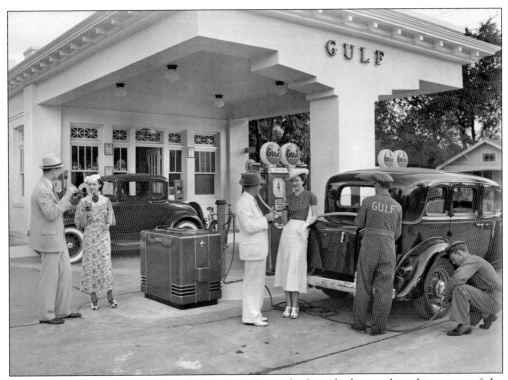

The Gulf Oil Company was founded in 1901. It was built with the combined interests of the famous Spindletop oil field. This photograph illustrates the high degree of customer service the company gas stations offered. In 1932, the Kelvinator refrigerator would keep the gas station customers' soft drinks ice cold.

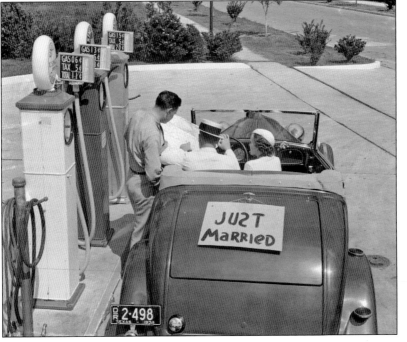

This Sinclair gas station was located in the 6500 block of Main Street right next to Rice Institute. In 1934, regular gas was only 6¢ a gallon and the attendant was always ready to help with directions.

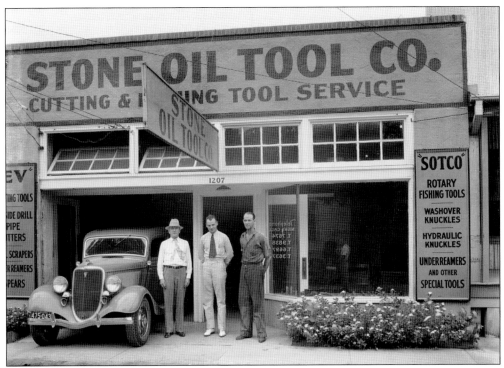

Stone Oil Tool Company was located at 1207 Maury Street. Earl Stone, the company's owner, is pictured on the left. In 1930, oil was putting $1 million a day into the Texas economy and supported businesses like Stone Oil Tool.

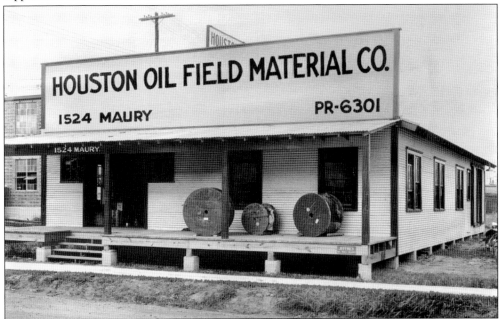

The Houston Oil Field Material Company was located at 1502–1524 Maury Street. It supplied just about anything a wildcatter would need to make a well. In 1932, there were nine oil fields within a 100-mile radius of Houston, creating the need for oil field service companies.

www.arcadiapublishing.com

Discover books about the town where you grew up, the cities where your friends and families live, the town where your parents met, or even that retirement spot you've been dreaming about. Our Web site provides history lovers with exclusive deals, advanced notification about new titles, e-mail alerts of author events, and much more.

MADE IN THE USA

Arcadia Publishing, the leading local history publisher in the United States, is committed to making history accessible and meaningful through publishing books that celebrate and preserve the heritage of America's people and places. Consistent with our mission to preserve history on a local level, this book was printed in South Carolina on American-made paper and manufactured entirely in the United States.

This book carries the accredited Forest Stewardship Council (FSC) label and is printed on 100 percent FSC-certified paper. Products carrying the FSC label are independently certified to assure consumers that they come from forests that are managed to meet the social, economic, and ecological needs of present and future generations.

FSC
Mixed Sources
Product group from well-managed forests and other controlled sources

Cert no. SW-COC-001530
www.fsc.org
© 1996 Forest Stewardship Council

Find Your Place in History.